IMAGES
of America

EAST GREENWICH

This book belongs to:

Gloria E. Mulhearn
200 Rumford St.
Concord, NH 03301

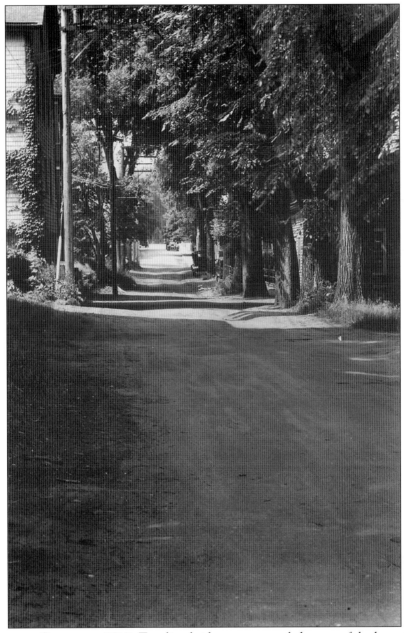

MARLBOROUGH STREET, C. 1910. Tree-lined side streets reveal the peaceful, charming nature of East Greenwich past. Main Street was paved in 1899, and the rest followed. Most of the trees were lost to Dutch elm disease or fell in the hurricane of 1938. (Gunderson photograph.)

On the cover: Please see page 34. (East Greenwich Historic Preservation Society collection.)

IMAGES
of America

EAST GREENWICH

East Greenwich Historic Preservation Society

Copyright © 2006 by East Greenwich Historic Preservation Society
ISBN 0-7385-4527-9

Published by Arcadia Publishing
Charleston SC, Chicago IL, Portsmouth NH, San Francisco CA

Printed in the United States of America

Library of Congress Catalog Card Number: 2006923205

For all general information contact Arcadia Publishing at:
Telephone 843-853-2070
Fax 843-853-0044
E-mail sales@arcadiapublishing.com
For customer service and orders:
Toll-Free 1-888-313-2665

Visit us on the Internet at http://www.arcadiapublishing.com

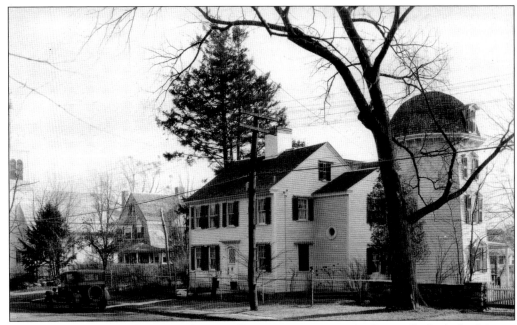

WINDMILL COTTAGE, DIVISION STREET, BUILT AROUND 1803. Originally built for Martin Nichols, a mariner, this house has had many notable owners. However, its most well-known period is when the famous American poet Henry Wadsworth Longfellow purchased it in 1866 for his good friend Prof. George Washington Greene and his family. Then, sometime before 1870, Longfellow also purchased the three-story shingled windmill situated at the old saltpeter works nearby and had it attached to the cottage. The property remained in the Greene family until 1907 when it was sold at public auction. Without doubt, Longfellow's poem "The Windmill," written in 1880, is about this mill-cottage. The property was placed on the National Register of Historic Places in 1973. This photograph was taken around 1927. (Stevens photograph.)

Contents

Acknowledgments		6
Introduction		7
1.	The Waterfront	9
2.	King Street and Below Main	19
3.	Main Street	29
4.	The Hill	51
5.	Frenchtown and the Outskirts	63
6.	Academia and Houses of Worship	77
7.	Early Mills and Industry	95
8.	Town Functions, Past and Present	105
9.	People	111
10.	Fry's Hamlet	121
Bibliography		127

ACKNOWLEDGMENTS

In 1927, the Town of East Greenwich celebrated its 250th anniversary. Emil A. Stevens was in charge of photography. Whether Stevens actually took all the pictures for the fete or coordinated gathering them up, many pictures were taken of the town and its people. Fifty years later, East Greenwich celebrated its 300th anniversary, and Stevens photographs were lent out of attics and albums for use in associated publications. Some people wanted them returned, some wanted them to be preserved for history. The East Greenwich Historic Preservation Society became the repository, and many of those pictures are used in this book. It is indeed fortunate that Stevens photographs are available and of such quality. Another photographer who took fine pictures represented in this book is Carl Gunderson, who had a studio, Ardslae, in the Masonic building on Main Street. Earnshaw photographs were often used on postcards. In the 1950s, Bucky Hoeffler took many pictures, some of which are in this book. We try very hard to credit where due, but unless the picture has a name on it, we can only guess. Therefore, pictures in this book without credit lines are in the collection of the East Greenwich Historic Preservation Society. Collection pictures that we know the origin will have the photographer's name listed below, followed by the word "photograph." Photographs that we were allowed to scan and then returned to their owners are part of a collection in the owner's name. Anyone knowing the history of any of these photographs is always invited to contact the society. We also acknowledge Bartons of Barton's Corner for their donation of old photographs of East Greenwich Academy to our organization. We also thank Leonard and Susan Curado for their research papers on the Long-Langford-Kenyon House.

<div style="text-align: right;">
Thaire H. Adamson, historian

Gladys I. Bailey, director

Alan F. Clarke, graphic artist

Marion Helwig, president
</div>

INTRODUCTION

It is with great pleasure we natives of East Greenwich welcome you to a history of our little town. While this book is a collection of early pictures and some history, we hope this piques your interest and makes you want to know more. Fortunately, East Greenwich, in its 300-plus years, has kept a pretty good account of itself. Its citizens have been literate, and there is much available should one want to learn more. The East Greenwich Free Library and the East Greenwich Historic Preservation Society both have many resources for historic and genealogical research. Several authors, past and present, have contributed to this book. They are listed in the bibliography.

Perhaps one of the most interesting is the text of a speech that Henry E. Turner delivered to the East Greenwich Businessmen's Association on April 11, 1892. Henry E. Turner was the grandson of Dr. Peter Turner, an East Greenwich physician in the Revolutionary War. Titled "Reminiscences of East Greenwich," Henry E. Turner's speech captures the color, character, and also a few characters of the town in the 19th century. In speaking of the town's seaport days, he says:

> The ancient captain, best known in Greenwich and longest associated with the Newport trade, was Captain Howland Greene of Greenwich. He lived in the Main street, at the north corner of the street coming down, opposite the Updike House, previously known as Colonel Arnold's Tavern, and then, as now, distinguished by the sign of the bunch of grapes, which, from the revolution to this day, has been the leading hostelry in East Greenwich. In my first recollection it would have seemed an unreasonable and almost impossible effort of imagination to conceive of any other method of reaching Newport than by Captain Greene's packet, as that class of vessels were then styled, but before many years the trade had changed, so that the sloops went more frequently to Providence than to Newport, and a regular packet-sloop, between Wickford and Newport, the old Resolution, owned by the Howlands and commanded in my earliest recollection by Capt. Wm. Holloway, Jr., and built in the year of my advent, 1816, afterwards run for many years, first by Thomas Holloway and then by Capt. Baker, the father of our Superintendent of Schools, had become the more usual mode of going to Newport, and even Capt. Howland Greene had adapted himself and made his trips as often to Providence as to Newport in his advanced life.
>
> Besides Captains Spencer and Greene, Capt. Benj. Miller was running a sloop, according to my recollection. His trade was almost exclusively confined to Providence. He was knocked overboard and drowned by the jibing of his sloop off Conanicut Point in returning from Providence, with only a young son on board, who succeeded in landing the vessel safely alone.

The papers and speeches of past citizens of East Greenwich illustrate what life was like in the early days of the town. It was a town of great wealth and not beyond a bit of poverty also. Always a town of many characters, Henry E. Turner describes one citizen as such:

> He was a contemporary of my grandfather and outlived him for several years. He was well known in Newport, having been often a member of the General Assembly, and he could not appear anywhere without being the subject of general observation. He was reputed to weigh somewhere about 400 pounds. He generally sat in a stoop in front of his house, such as I

recollect, on several of the houses in Greenwich, with a large square top step with a railing on two sides and a flight of steps on the up-hill side; the lower side being much higher, owing to the sharp grade, was without steps, and the two railed sides were supplied with wooden seats. The platform at top being about five feet by six, accommodated a reasonably sized family party.

[His] house was on the north west corner of Marlborough and King streets, and I have many hundreds of times seen him sitting in his stoop, which was his constant habit in suitable weather, his immense size being a disqualification for much active exercise.

[He] was remarkable for the power of his voice, and it used to be said that when he read the newspaper aloud the whole village could benefit by it. [He] had a farm in Frenchtown called the Burrow, and whenever he had occasion to visit his farm he occupied the body of an old-fashioned chaise, capacious in size, and intended for two full grown persons, which would accommodate him alone with nothing to spare. The chaises of the class and date of [his], which were even then superseded by the calesche or bellowstop, of which there were several in use about Greenwich by the older people, had a square top and looked as if they might date back to some period not much later than the flood, and were opprobriously nicknamed by the boys and the profane roughs, tobacco boxes.

Yes, the town has enough history to satisfy the needs and wants of the casual tourist or serious historian, yet much history has been lost to the bulldozer. The town waited until 1976 to pass historic district zoning. In September 1979, the Olde East Greenwich Community Improvement Association was formed by a group of residents and property owners desiring to upgrade their King Street neighborhood. Their area included from Rocky Hollow Road to Division Street, and Main Street to the waterfront. It was a result of their petition the prior year to get new sidewalks on King Street. There had been a gradual turnover of houses with the new owners making improvements to their property. From mostly rental property, now many of the homes are owner occupied. The headline of the *Rhode Island Pendulum* of August 20, 1980, is "Renaissance below Main Street." One of the new owners said the buildings were a great historic heritage, but many of the buildings had been cut up into apartments and nothing spent on upkeep. Jeanne Smith said, "The good thing about having this area neglected for so long was that people were so poor they couldn't do anything about changing the styles in the houses." The article credits the East Greenwich Historic Preservation Society for starting the movement several years before when it purchased the Old Kent County Jailhouse from the town for $1 to use as its headquarters. The 1980–1981 awards by the chamber of commerce for new buildings and renovations of old ones included four renovations on King Street. In 1986, historian Richard E. Greenwood, a Brown University graduate, conducted a survey of architecturally important buildings in the town's historic district, which includes King Street. The survey included title searches, inventory of the features of the buildings, and checking available historic documents and pictures, including the collection of the East Greenwich Historic Preservation Society, all information to help pinpoint the dates of the homes. This information serves as a guide to those who wish to restore their properties and to help keep them private homes not commercial establishments. In 2005, a concentration of over two dozen important Colonial and early Republican structures remain, many in excellent state of preservation or in process. King Street is almost a solid row of early buildings from the old jail at its foot to the Kent County Court House (now East Greenwich Town Hall) "at the head of the gutter" as it was called in early days. There are continuing improvements to the homes and the street with sidewalks and plantings, and condominiums in the old Bay Mill. There is still a lot of traffic on King Street going to boatyards, boat moorings, the East Greenwich Yacht Club, and a number of fine restaurants. In the words of restoration contractor Chris Brayton, "Transforming abandoned or neglected properties into dwellings, offices, and shops strengthens the community and widens the tax base, while preserving the unique character of the area."

One
THE WATERFRONT

This was where the town began, the hub of its industry and activity. Principal access was by water. There were numerous wharves, docks, and storehouses. It would have been a beehive of activity with boatbuilding and repairs, rope making, fishing, shell fishing, and loading and unloading of vessels, many owned by local people. There were a number of wharves: Custom House Wharf, Wanton Casey's and Arnold's near the Ferricup or Steamboat Dock, the Brown and Turner Wharf, Glacier's Dock, and Jail Wharf.

This area shipped mules, horses, potatoes and other vegetables, salted fish, and other seafood. Scallops were very plentiful, and even the shells were sold, collected, and barged to New York to be used in foundation materials. The Shore Mill was built in 1827 and over the years continued under various names.

One section of the waterfront became known as Scalloptown because of the large catches and huge piles of shells. This was an area of shanties and barrooms and occasionally a bit of lawlessness.

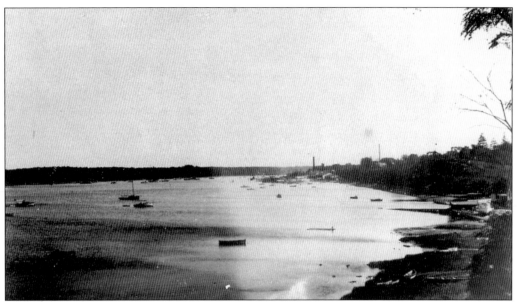

CHIPIWANOXET, ON THE WARWICK SHORE. This is a view to the south along the western shores to Greenwich Cove. Chipiwanoxet, originally an island and now connected to the mainland, was the home of the Gallaudet Aircraft Corporation in the early days of aviation. All buildings were lost in the hurricane of 1938.

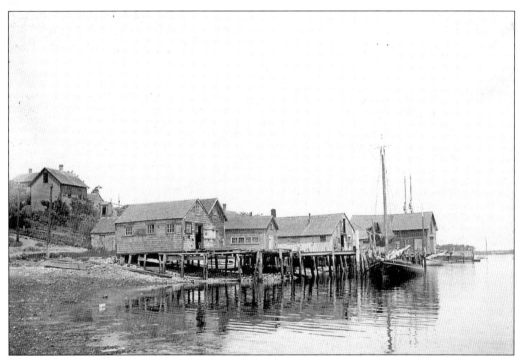

FISHERMEN'S SHANTIES ALONG THE WATERFRONT. In earlier days, Greenwich Cove was deep enough to allow large draught schooners right up to the docks. In this scene, obviously at low tide, the water is still deep enough for a sailboat to remain upright. Sadly those days are over, as the cove is very shallow and filled with silt.

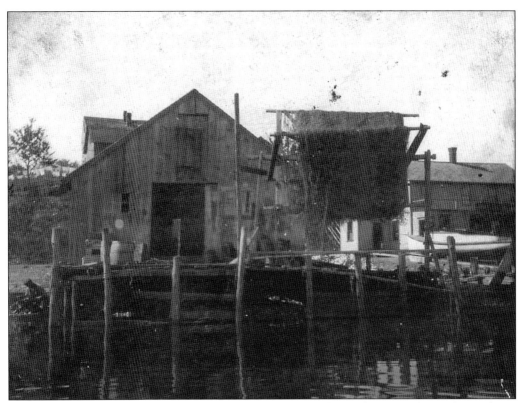

WATER STREET, c. 1910. A fisherman's shanty with fishnet drying racks is shown here. (Ellis collection.)

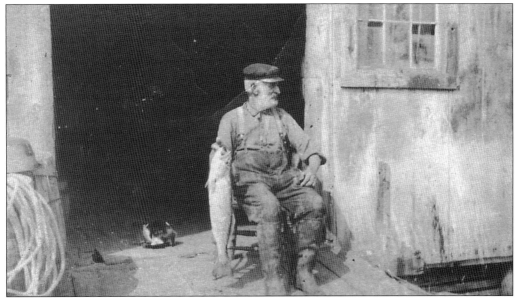

ELISHA R. MITCHELL. Elisha R. Mitchell, who lived on the hill up over the cove, ponders his fish and perhaps wonders if he might find someone he can get to clean it for him. (Ellis collection.)

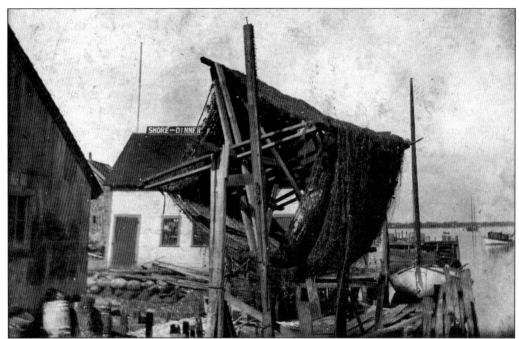

WATER STREET FISHING NETS, c. 1910. These are fishing nets drying on racks along the shore. (Ellis collection.)

SHED AT JOSEPH GREENE'S ROPEWALK. An early and fascinating industry was that of rope making. From 1766 until 1837, the ropewalk dominated the town as it ran along a high hill from Rocky Hollow Road to King Street. When the railroad came along, the hill was cut down and tracks laid where Joseph Greene used to walk slowly backward, twisting the strands of hemp into rope. This structure, his shed, stood on Castle Street until recently.

SOUTH WATER STREET, C. 1930S. Before the hurricanes changed the East Greenwich waterfront forever, people lived in Scalloptown shanties in leaner days. Things could accumulate. Note the old cars. (Drew collection.)

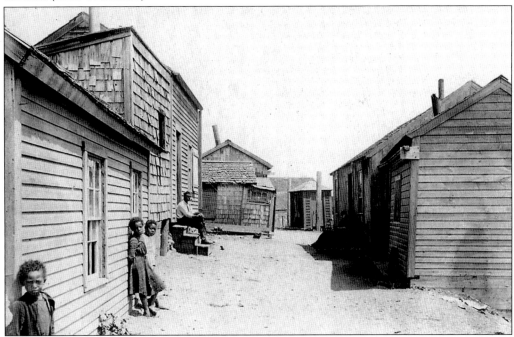

FARTHER UP WATER STREET. Where Water Street meets London Street, this picture shows more shanties and some of their inhabitants. Some of these buildings had burned in 1926 and all were gone by the mid-1950s. Today there is a children's playground and municipal facilities in this area.

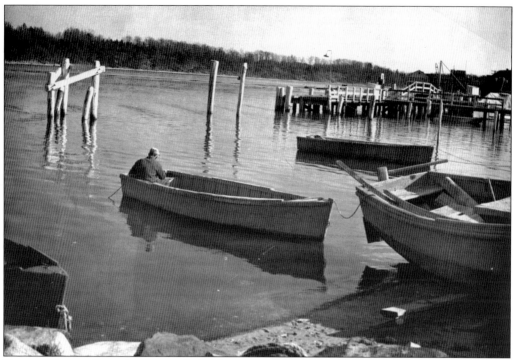

FISHING BOATS. In earlier times, shell fishermen and their workboats (skiffs) were towed out to the fishing grounds. Then came outboard motors. (Hoeffler photograph.)

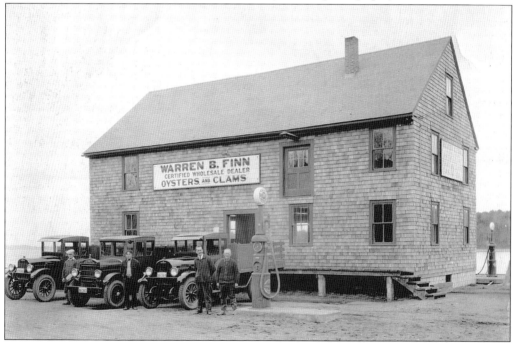

WARREN B. FINN WHOLESALE SEAFOOD MARKET, WATER STREET. The Finns have been buying quahogs (quahaug is the Native American spelling) and other shellfish from local fishermen for over 80 years. The business and building still exist today. (Earnshaw photograph.)

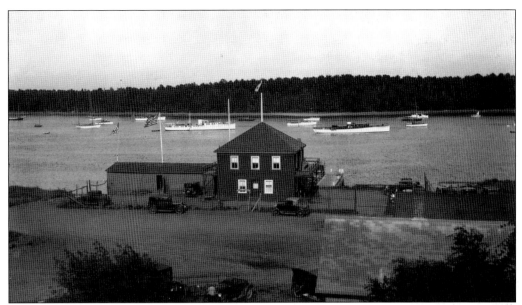

EAST GREENWICH YACHT CLUB, C. 1930. Located at 10 Water Street, the East Greenwich Yacht Club clubhouse for many years was part of the Champlin Lumber Company. The club was organized on August 19, 1909. Shown in this photograph at left is the yacht *Sea Dream*, owned by Paul C. Nicholson of Nicholson File Company. To the right is the *Gilnockie*, a 90-foot-6-inch, diesel-powered yacht belonging to Col. C. Prescott Knight, owner of Greyholme and Quidnessett Farms and five other farms.

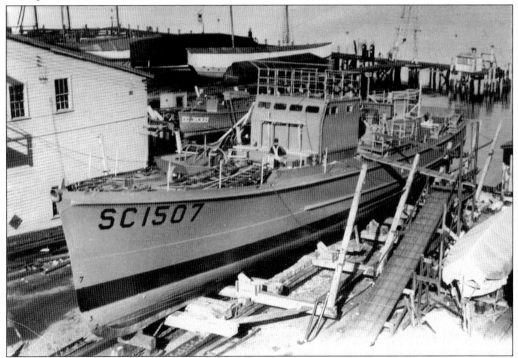

SHIPBUILDING DURING WORLD WAR II. Work is in progress on subchaser No. 1507 at Harris and Parsons Boatyard on Water Street. (Rice collection.)

EAST GREENWICH WATERFRONT AND THE HILLS BEYOND, c. 1920. This is the view as seen from the shore across the cove at Goddard Memorial State Park. Water Street comes down the hill on the left.

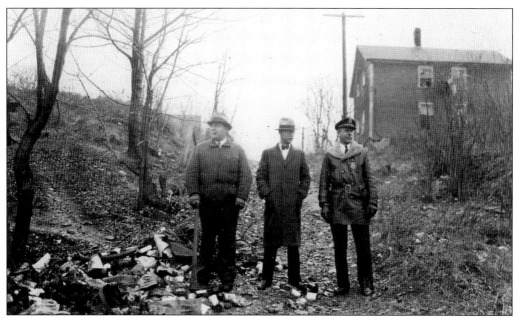

THE HURRICANE OF 1938. Town officials, standing on the Long Street hill, look at storm damage in Scalloptown. From left to right are Charles Sweet, Herbert Couper, and police chief Harold Benson.

LAZIER DAYS IN OLD SCALLOPTOWN. Looking north from a high bank over Greenwich Cove, on the opposite shore is Goddard Memorial State Park, a gift to the people of Rhode Island for use as a public park by members of the Goddard family on November 7, 1927.

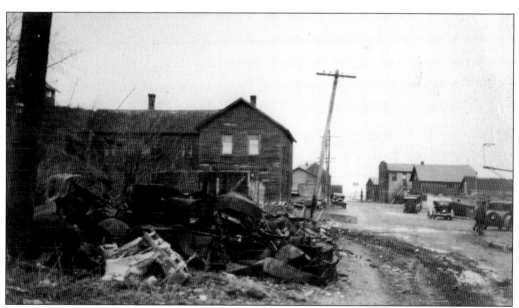

WATER STREET AFTER THE HURRICANE. This is looking north toward Queen Street. The house on the left is the Rice home, with the Bayview Café downstairs. The building with false front on the right is today the Harborside Lobstermania restaurant.

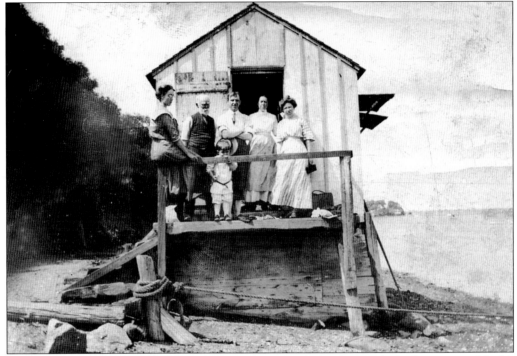

SUMMERTIME, c. 1910. Some folks are enjoying a few moments at a little shanty near Nock's Shipyard (now Norton's). Gertrude House is pictured on the left.

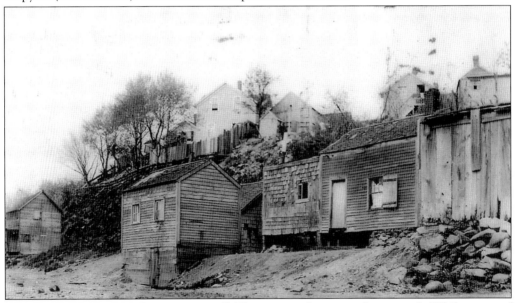

"RESIDENTIAL SECTION SCALLOPTOWN." This postcard seems a bit cynical. While some of these buildings were used as residences, most had seen better days and were used to store fishing gear and other items. Regarding Scalloptown, Nancy Allen Holst wrote, "One of the pleasant features of Scalloptown when I first purchased [my] shanty was the number of artists on summer days, busily sketching and painting that picturesque stretch of waterfront copiously adorned with weather-beaten fishermen's shanties that had never known the touch of a paintbrush."

Two

King Street and Below Main

Principal access to East Greenwich was by water, and this area was the heart of the town. Coastal trade was maintained by a line of sloops and schooners carrying passengers and freight.

King Street with the Town Wharf, 100 feet long and 40 feet wide, at its foot, was a busy spot. There was boat building, rope making, shipping and fishing, and even a short-lived whale fishery, and the coastal packet business prospered. Large seagoing vessels often docked here, and people would gather to watch them unload.

The dream of becoming a great port ended with the Embargo Act of 1807, stopping trade and leading to the War of 1812. The coastal packet trade ended with the coming of the railroad in 1837. The old families left King Street, retail stores and homes were built on the road through the center of town, and activity shifted to Main Street.

In the early 1970s, Edwin Gregory, an architectural student at Rhode Island School of Design, required to "take a Rhode Island building and renovate it," chose the old Mathewson Warehouse located behind the old jail. For his final thesis in 1974, he chose the restoration of King Street. Part of his work was funded by the East Greenwich Historic Preservation Society, and he noted that much of his information of the area was given to him by Marion Fry, the society president. He has now finished his third renovation on King Street, and he does the painstaking work himself.

The town passed Historic Zoning in 1976 and encouraged renovation. The area covering the original village became known as the Hill and Harbor District. An article in the *Rhode Island Pendulum* called the area a great historic heritage and having been neglected for so long was a good thing because the styles of the houses had not been changed. It credited the East Greenwich Historic Preservation Society with starting the movement when it purchased the Old Kent County Jailhouse from the town for $1 for use as its headquarters.

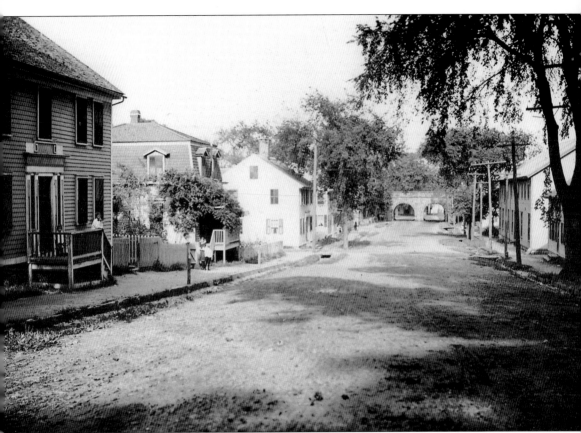

KING STREET. In 1750, Kent County was set off from Providence County and incorporated the towns of East Greenwich, Warwick, West Greenwich, and Coventry. East Greenwich was designated the shire town, and John Peirce gave land for a courthouse, which was not completed until 1771. In 1804, it was enlarged by Oliver Wickes and a new jail erected at the foot of King Street. Public life of East Greenwich centered on the courthouse. Here the town council met, and on Sundays, services were held by various churches. Directly across from the courthouse leading down the hill to the bay was King Street. It was the main street of the town up until the time of the Civil War. In the center of the village, it was one of the finest residential areas. Sea captains had built fine homes along King Street, showplaces of their day, as many who worked on them were also ship carpenters for part of the year.

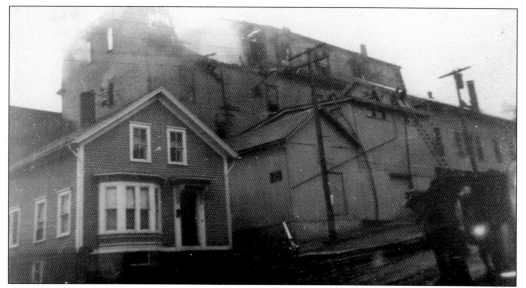

THE CAPTAIN SANDS HOUSE, 13 KING STREET, BUILT 1860S. There was no building at 13 King Street on the 1855 map, but there was by the 1870 map. Two large elm trees originally stood in front. Capt. William A. Sands (1812–1863) sailed for a New York firm. He was described as a handsome man who dressed in the finest fashion with shirts made by a London tailor. His mother, Abby G. Sands, at one time ran a school for young ladies in the lower level of the house. The Sandses are buried in the Wickes Cemetery on Division Street. In this picture, the Oddfellows hall, a building on Main Street, is burning. It was totally destroyed.

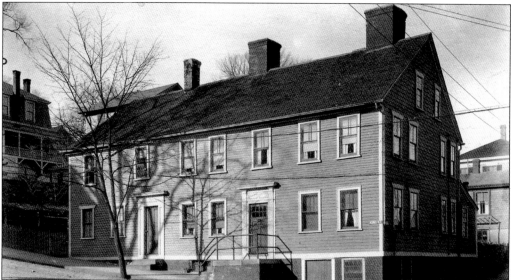

THE NATHAN WHITING HOUSE, 18–20 KING STREET, BUILT AROUND 1811. Nathan Whiting was born in 1774. He graduated from Rhode Island College (Brown University) in 1796, was admitted to the bar, and moved to East Greenwich. In 1811, he married Sarah (Sally) Salisbury, daughter of Jonathan and Sarah (Soule) Salisbury. Nathan Whiting died in 1842, his wife in 1845, and they are buried in East Greenwich Cemetery. Recently, Michael and Jane Morra, after consulting with the Providence Preservation Society, began restoration. Five fireplaces were found hidden behind walls. In one cellar, the remnants of an old umbrella shop were found. (Stevens photograph.)

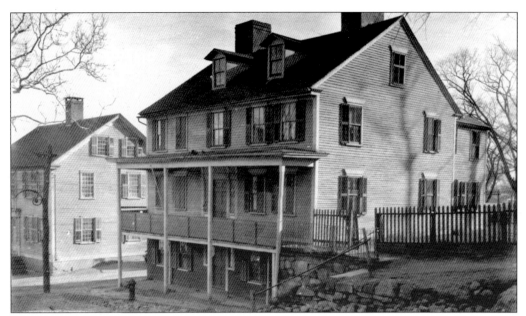

THE CAPTAIN JONATHAN SALISBURY HOUSE, 19 KING STREET, BUILT AROUND 1785. Jonathan Salisbury (1753–1823), captain of a Grand Banks fishing vessel, built this two-story house with a central pediment doorway. He was described as a giant of a man weighing close to 400 pounds with such a loud voice that the boys of the village were frightened of him. He would sit on the piazza and read the newspaper aloud, and people would come to listen. The house has 13 fireplaces with the original mantles and wide floorboards.

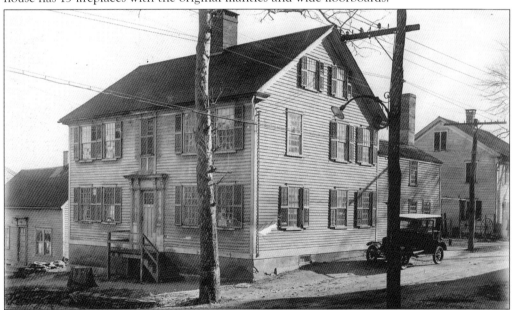

THE CROMWELL SALISBURY HOUSE, 21 KING STREET, BUILT AROUND 1780. Cromwell Turner Salisbury (1792–1859) married Lydia Peirce, daughter of Stephen and Lydia Peirce. They had six children. He also is said to have been a large man and a blacksmith, with a shop located down King Street on the corner of Exchange Street. Cromwell Salisbury manufactured his own metals from raw material and fashioned andirons, kettles, shovels, and other tools of brass and tin.

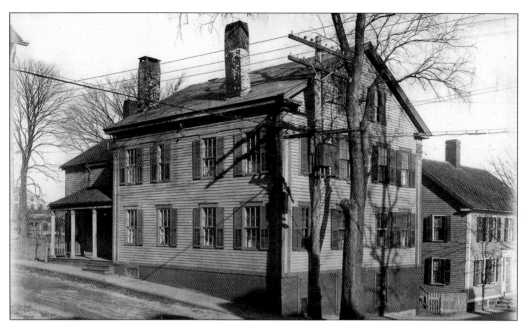

THE JAMES PEIRCE HOUSE, 24–26 KING STREET. This house on the corner of Marlborough Street originally was the site of the Upton Kiln where earthenware was manufactured by Isaac and Samuel Upton, two brothers who had come to East Greenwich in 1771. Later James B. Peirce, Esq., built the house here. Peirce was a partner of William P. Salisbury in the hay and grain business. At one time, he was also a partner in the Bay Mill.

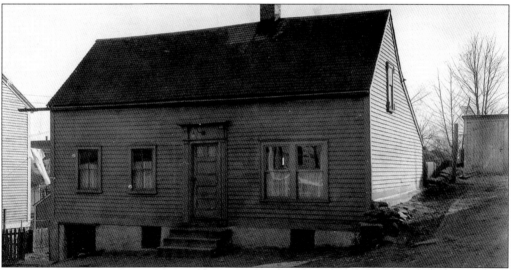

THE NATHANIEL HALEY HOUSE, 27 KING STREET, BUILT AROUND 1749. This house has been beautifully restored by Edwin Gregory, a former curator at the Rhode Island Historical Society, to as close to the original as possible. It is a Colonial saltbox, one story with gable roof and rear lean-to. It is also known as the Heffing-Johnston place but also at one time was the home of Seneca Spencer, a boot maker and great-grandson of John Spencer, one of the original town settlers. There is a big square chimney, a long lean-to with roof that almost touches the ground, and a front door so low a tall person has to duck to enter. In the east end of the basement, J. H. Johnston kept a grocery store.

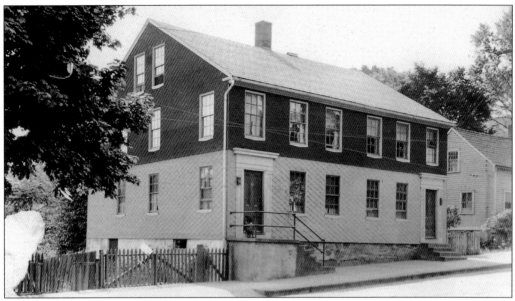

THE WEAVER HOUSE, 31–33 KING STREET, BUILT AROUND 1800. A duplex of early Republican architecture, this house was built by a member of the Weaver family, and very little is known of its history. In 1982, a community improvement award was given by the East Greenwich Chamber of Commerce to Dorothy and Edward Madden for the restoration. At the right end of the picture sits the Squire Wall House. Squire Wall was sheriff of Kent County and keeper of the jail. Wall married Hannah Cooke in 1742, and they had eight children.

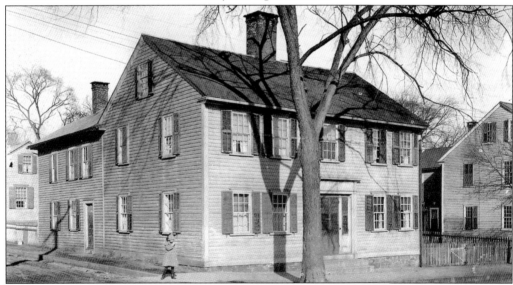

THE NATHANIEL COLE HOUSE, 42 KING STREET, BUILT AROUND 1800. This house is on the corner of King and Duke Streets, facing King but with a long ell and outside door on Duke Street. Nathaniel Hunt Cole, son of Samuel and Rebecca T. Cole, was born August 25, 1783, and died January 22, 1885, aged 101 years. He married Phebe Wickes, daughter of Oliver and Abigail Wickes. She was born in 1785 and died in 1870 aged 85 years. They are buried in East Greenwich Cemetery. Nathaniel was called a jolly old man with all his faculties who even voted at age 100.

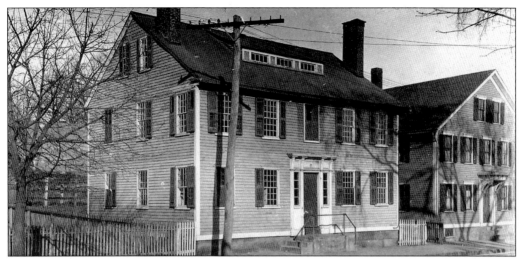

THE VARNUM BAILEY HOUSE, 50 KING STREET, BUILT AROUND 1820. This is called one of the finest houses on King Street, an architectural gem. It has a distinctive front door with double stairway to the sidewalk, 12-over-12 windows, and a row of three small windows along the roof. The sign on the house says "Captain Aldrich, 1797." At the right is the David Whitford Hunt House at 54 King Street. This Colonial–Greek Revival house was built with the gable end to the street, unlike all other houses on the street. David Whitford Hunt, son of George and Sarah Hunt, was born in North Kingstown in 1798 and died in East Greenwich in 1862. In 1820, he married Mary (Marcy) Sherman. (Stevens photograph.)

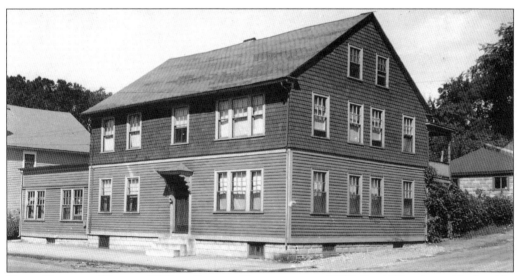

DAVID PINNIGER HOUSE, 66 KING STREET, BUILT AROUND 1800. David Pinniger, a blacksmith, married Elizabeth Arnold, daughter of Capt. Thomas Arnold, in 1796. He built a big house with two large square chimneys. The house was well built with beautiful Colonial woodwork throughout. He had five sons who all became sea captains. His father-in-law, Capt. Thomas Arnold, lived with them at one time. He had served as an officer in the Revolutionary army and lost his right leg at the Battle of Monmouth. Captain Arnold was appointed first surveyor for the Port of East Greenwich by George Washington. As surveyor, he had charge of the customs house. (Stevens photograph.)

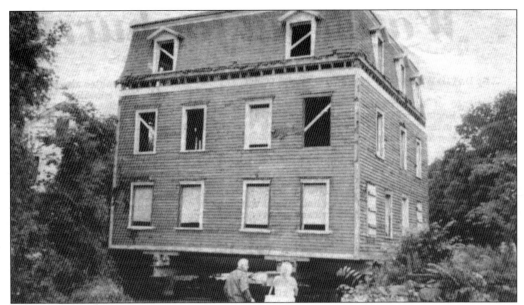

AN 1870 HOUSE MOVED. This house formerly stood between 63 King Street and the Arch Railroad Bridge. A three-story house with mansard roof, it was moved west along King Street and north up Crop Street during the summer of 1985. It was relocated, restored, and converted into condominiums. A previous house belonging to Marcy Ann Greene, which had stood on this site, was burned. The land on which this house stood is now parking lots. (Pendulum photograph.)

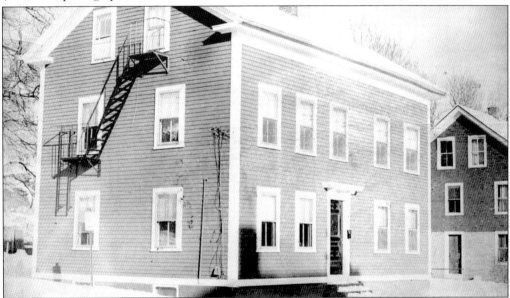

THE HOUSE OF FRITZ JOHNSON, 70 KING STREET. This house, on the corner of King and Crop Streets, is on the site of the old Potter Pollard place, built by a sea captain engaged in the East Indian trade. Fritz Johnson had a stable and sold horses. According to the *Rhode Island Pendulum* of March 27, 1924, "Fritz Johnson's Stables on King Street were scene of a lively auction yesterday when 30 horses shipped from North Dakota were sold at public auction. The average price was about $65. The drive of 30 horses through the streets was an interesting sight." (Pendulum photograph.)

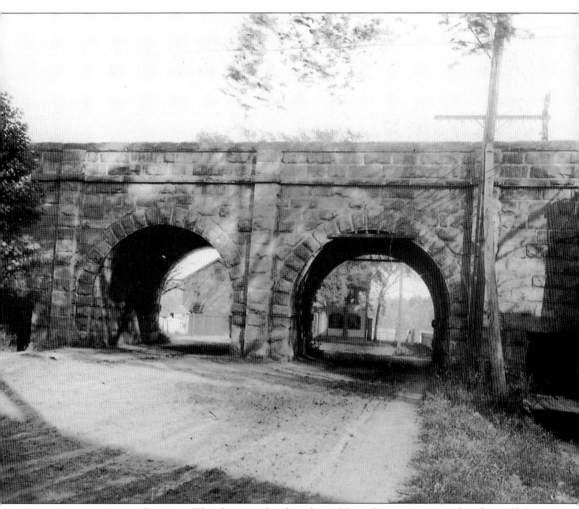

KING STREET ARCH BRIDGE. This historic landmark on King Street was completed in 1836, when the Stonington Railroad extended its line through East Greenwich. Ropewalk Hill had to be cut back before the tracks could be laid. The bridge over King Street was built of locally quarried granite. Maj. William Gibbs McNeill, chief engineer of the railroad, designed this handsome stone bridge along with Maj. George Washington Whistler, father of the famous American painter James McNeill Whistler. Major Whistler had worked on a number of railroads in this country. His son James is most famous for the painting of his mother. The Providence and Stonington Railroad was completed in 1837. The station on Duke Street was a busy place with passenger and freight service. These tracks are now used by Amtrak.

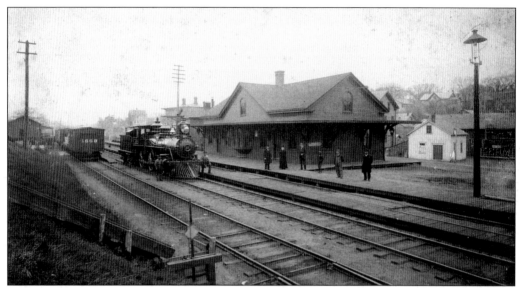

EAST GREENWICH RAILWAY STATION IN 1889. In November 1837, the Stonington Railroad began service and changed forever the topography of the town's waterfront. The railway company was not expecting much business and erected only a small station on Duke Street. In 1876, now operating under the name of New York, Providence and Boston Railroad Company, records show that 34,300 tickets were sold at the Duke Street station. In 1888, service was extended to Boston. In 1893, the railroad changed hands to the New York, New Haven and Hartford Railroad, which built the above one-and-a-half-story, beautiful late Victorian structure. In 1900, 17 daily trains were running each way between East Greenwich and Providence. Behind the station rises a large three-story building, which was once a hotel operated by the Miners. It has since been razed. (W. B. Davidson photograph.)

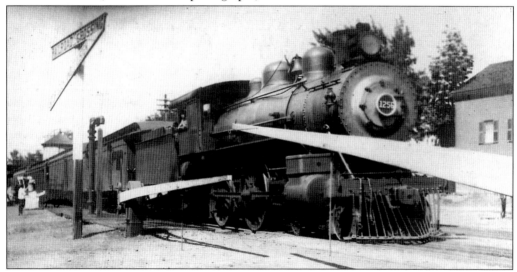

BUSIER DAYS ON DUKE STREET. Seen here are steam engine and freight cars idling before the station in June 1908. The building on the right was a workshop and living quarters for New York, New Haven and Hartford Railroad workers. In 1930, it was auctioned off. Louis Maddalena bought it for $25 and paid $100 to have it moved to where it now rests, at 15 Lion Street. (Maddalena collection.)

Three

MAIN STREET

When East Greenwich was a young seafaring town and transportation was by the sea, King Street was the main thoroughfare. The decline of coastal trading and the coming of the railroad found the town taking a different direction.

Houses and stores had been built along the road running through town, which now became Main Street. There were horse hitches and large elm trees. In 1899, Main Street was macadamized. In 1900, an electric railway, the Seaview Railway, came from the south as far as First Avenue, with connections to the United Electric Railway for points north.

As early as 1760, Arnold's Tavern was a regular stagecoach stop. The tavern evolved through several names, buildings, and ownerships and is now the Greenwich Hotel. It had been the site of many town and social meetings, and a special event took place on September 2, 1774, when 54 men of Kent County met at the Arnold's Tavern and formed the Kentish Guards, a Rhode Island militia still in existence.

Remaining early houses built on Main Street are the Brick House, 1767, and Abraham Greene House, 1770. The old Queen Anne–style Victorian town hall erected in 1885 was razed in 1964.

In 1750, when Kent County was set off from Providence County, East Greenwich was designated as the county seat. A courthouse was built on Main Street, facing King Street. Replaced in 1804, it still stands and now houses the East Greenwich Town Hall.

Stores of many variety, restaurants, theaters have come and gone on Main Street over the years. The venerable elms disappeared as did the horse hitches, railways, privately owned groceries, and other businesses.

MAIN STREET, LOOKING NORTH. The Kent Theatre, formerly the USO Club building, is on the left, and adjoining that is the Ross Aker Furniture store. This area is the site of the old Drysalters Mill. On the right is the former Our Lady of Mercy Catholic Church property since 1870. In 1979, it became a shopping center, when a new church was built a few blocks away.

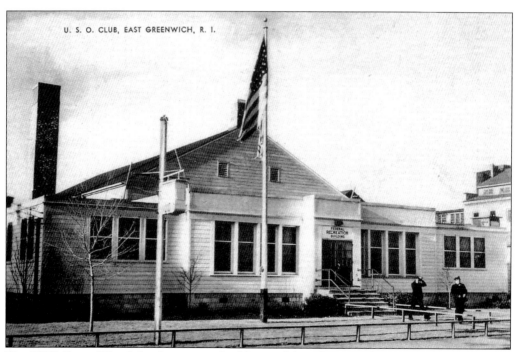

THE USO CLUB. This federal recreation building on Main Street at the corner of Greene Street was built during World War II. In 1946, it was officially closed, and the building was converted to a movie house, the Kent Theatre, in 1947. In 1995, it was razed. The Centreville Bank now stands on the site.

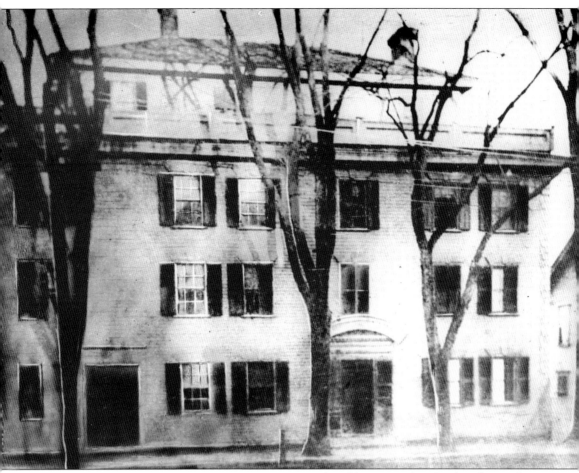

ARNOLD'S TAVERN, 162 MAIN STREET. A Main Street hotel has existed at this location under various names since the 1700s. As early as 1740, there were buildings on this site belonging to James Greene. In 1770, Col. William Arnold (1739–1816), probably the best known and most successful of the early shipping merchants of the area, ran the inn. His wife and nine children made their home there. The inn was a large one for those times. Originally a wide hall led right through the center of the building, with two great rooms on each side. A reception room was to the right of the entrance. Outside, over the door, hung a wooden sign representing a cluster of grapes, so the tavern was called both "The Bunch of Grapes" and "Arnold's Tavern." About 1825, Daniel Updike (1761–1842), who had married Colonel Arnold's daughter Ardelissa, assumed management of the inn. At this time, the name was changed to the Updike Inn. Town events, such as court week, meetings of the general assembly, and the quarterly meeting of the Quakers, found the 34 rooms of the hotel filled to capacity. In 1896, the old inn was torn down to make way for the new modern hostelry that stands here today. Many celebrated personages have tarried here when traveling via the old Post Road. In 1928, under the operation of Kenneth Allen, the name was changed to Greenwich Inn. In 1951, Michael Romano purchased the inn. After several following owners, it is now known as the Greenwich Hotel. In the 1940s and 1950s, the rooftop lounge attracted popular bands and patrons from around the state. At present, Anthony Joseph and daughter Joann have been working to restore the three-story hotel to its former glory. The upstairs function room had a new roof installed in 1993 after the old roof collapsed. Windows run the length of most of the walls in the 34 guest rooms. There are two balconies on the hotel's front, with intricately curled iron railing.

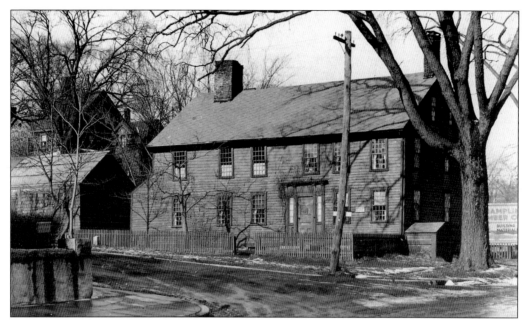

THE JEREMIAH PIERCE TAVERN, BUILT AROUND 1711. This building once stood at the northwest corner of Division Street and Post Road. It later belonged to John Mawney, the postmaster. The East Greenwich Post Office was kept here by Mawney for 32 years even though the building was just across the line in the city of Warwick. Mawney also held the office of collector for the Port of East Greenwich for 39 years. (Stevens photograph.)

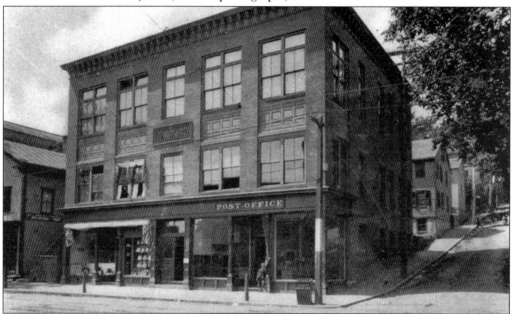

THE MASONIC BUILDING, BUILT 1893. Located on the southwest corner of Church Street and Main Street, this building housed several businesses through the years. It was the home of the post office on the right-hand corner storefront until 1935. Prior to 1800, mail services were performed by a stagecoach, which carried passengers from Kingston to Providence one day and returned the next.

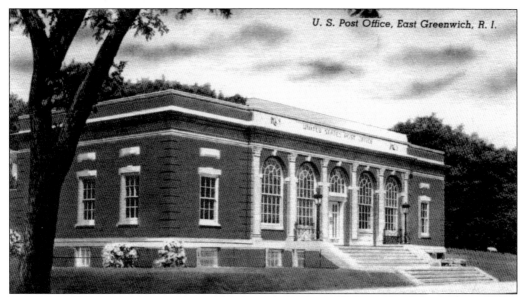

EARLY-20TH-CENTURY ARCHITECTURE. This former post office was located on the southwest corner of Division Street and Main Street. This post office opened for business in August 1935 and closed in 1977, after a new one was completed in 1976. Today this fine brick building houses a restaurant.

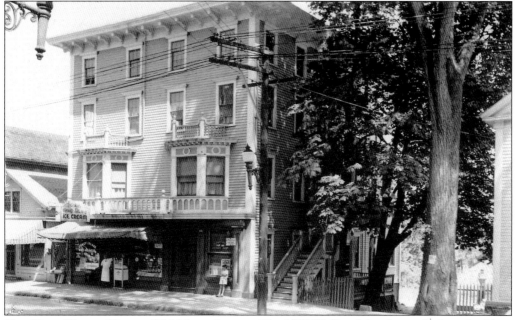

THE KENT HOUSE HOTEL, 254 MAIN STREET. The 1855 Walling Map shows the large building on east side of Main Street between Queen and Long Streets. A personal advertisement in the *Rhode Island Pendulum* on June 20, 1857, noted that a Mrs. Brown informed all that she had not gone west and was prepared to accommodate boarders and transients at Kent House. The 1879 Picture Map of East Greenwich shows the size of this large four story building. In 1882, the Kent House, also known as the Dennison House, which was built by Roland G. Brown, was sold to Dr. E. G. Carpenter, who occupied it as an office and residence. (Stevens photograph.)

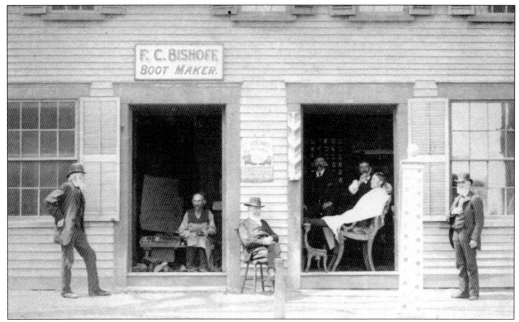

STANHOPE HOUSE, BUILT AROUND 1755. This building still stands at the corner of Main and Armory Streets. This picture was taken around 1900 and shows Cheney Bishoff in his boot shop. In the barbershop are Jim Bennett, barber Fred Prefontaine, and Harry Abbott. At the right, is Edward Stanhope Taplin. The other two gentlemen are unidentified.

THE JOSEPH GREENE HOUSE, "STIRLING CASTLE." This building was built about 1776 at the corner of Main and Peirce Streets. It was razed in 1956 and is now a parking lot. Joseph Greene also owned the ropewalk on Castle Street, where rope was manufactured for the lucrative shipping trade.

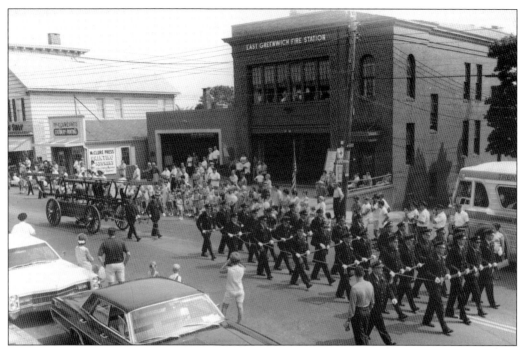

FIREMEN ON PARADE. The hand tub *Volunteer* and local firemen pass in review in front of the fire station on Main Street in a parade leading up to an old-fashioned New England firemen's muster. Old hand pumpers converged during the summer to have contests to see which of the old tubs could send a water stream the longest distance. Such events were usually accompanied by a carnival and other festivities. (Firemen's Association photograph.)

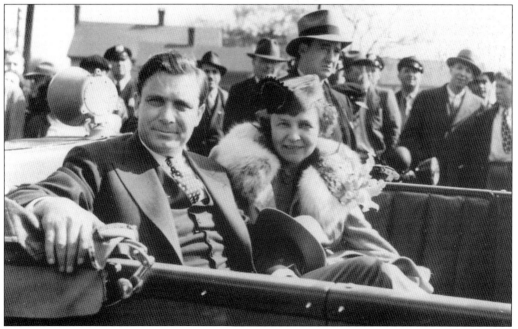

VIP ON MAIN STREET. Republican presidential candidate Wendell Wilkie and his wife pose in an open convertible car around 1940. Wilkie ran against Franklin Delano Roosevelt and lost.

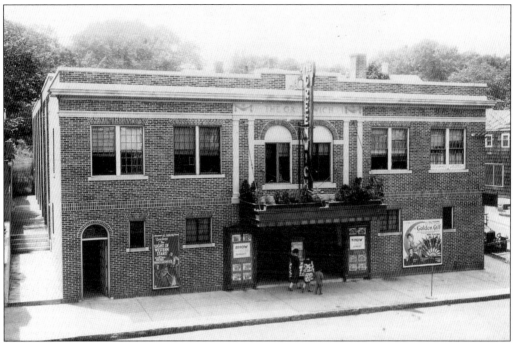

THE GREENWICH THEATRE, MAIN STREET. Opening to silent movies in 1926, in May 1933 the first talking picture movie was shown. After changing hands a few times, it was finally purchased by the Erinakes family, who also owned the Kent Theatre. The family turned this building over for $1 to the nonprofit Odeum group. Today the Odeum is an integral part of entertainment in the town.

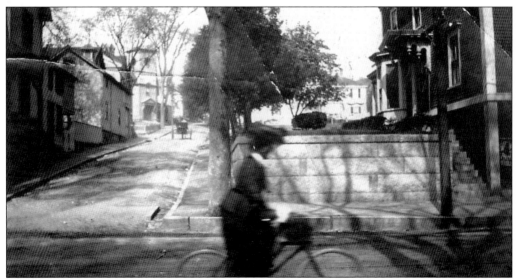

MAIN STREET, LOOKING WEST UP MONTROSE STREET. This is a scene from an earlier time, as noted by the Victorian lady bicyclist. Looking up the hill at left is the First Baptist Church. At right are the home and offices of Dr. Fenwick G. Taggart, the local physician for 50 years.

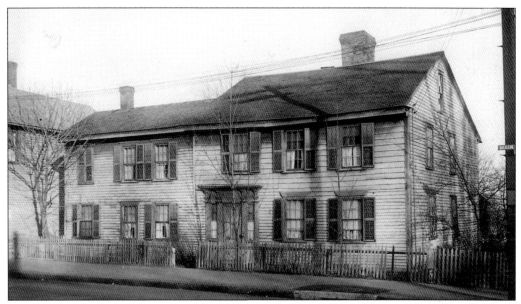

QUESTIONABLE ORIGINS. It is not known exactly when this house was built, but the land belonged to John Heath, and a building stood there on the corner of Main and London Streets as early as 1712. A smaller house was probably on the lot in earlier days. John Heath was one of the few founding fathers who was literate, serving in several town offices. This house was razed to make way for a gas station in 1940. (Stevens photograph.)

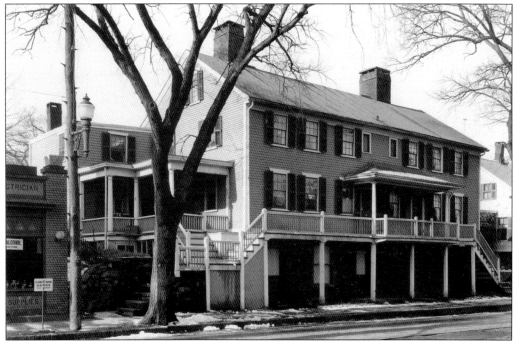

DAN BROWN'S PERIWIG SHOP, BUILT AROUND 1749, MAIN STREET. A periwig was the wig worn by men in the 17th and 18th centuries. This building was located on the west side between Division and Melrose Streets. It was razed in the 1930s to make way for the new post office.

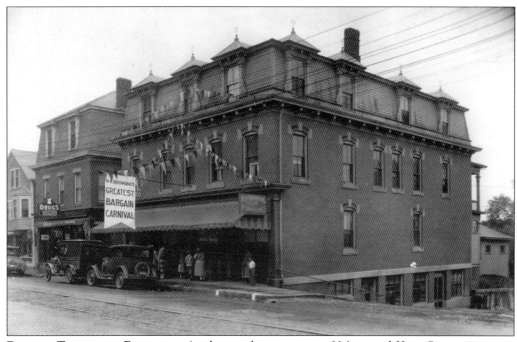

RECENT TELEPHONE BUILDING. At the northeast corner of Main and King Streets is now a large brick building facing Main Street. This property, once known as the Browning Block, earlier was the site of the John Tibbitts Tavern and until recently was a telephone office.

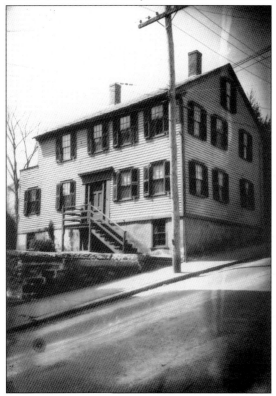

MOWRY-LEBARON HOUSE, BUILT AROUND 1790. In 1877, Dr. D. H. Greene wrote in his *History of East Greenwich* that this house on the corner of Main and Meeting (now Church) Streets and opposite the Updike Inn (Greenwich Hotel) was owned by Lydia LeBaron. She was Dr. Greene's aunt, the sister of his mother. He further noted that the Woolen Cards Manufactury, begun about 1790 by Earl Mowry, was located in this dwelling house. The *Pawtuxet-Valley Gleaner*, a weekly newspaper, on July 21, 1893, noted, "The house at the corner of Main and Church Streets is being removed back on the lot ready for the Masonic Lodge." It has since been razed for a parking lot.

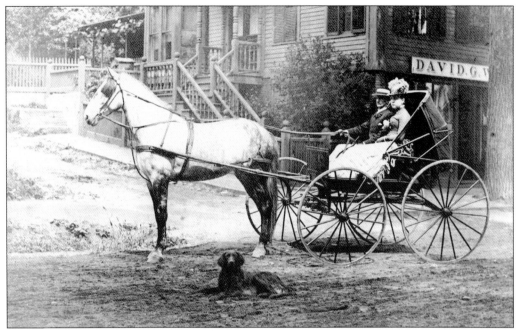

HORSE AND BUGGY DAYS! Annie N. Jester (née Shippee) and her husband, Benjamin Butler Jester, pause for a picture in front of the residence situated on Main Street at the corner of Academy Lane. Since this picture was taken, in 1885–1890, the building has been renovated several times, and restaurants have since occupied this house.

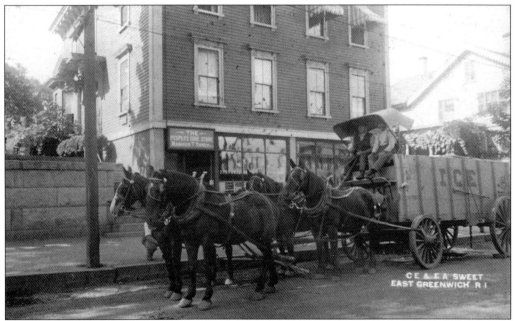

THE ICE MAN COMETH. Ice is being delivered on Main Street in the late 1800s by the C. E. and E. A. Sweet Company. The ice was cut from Bleachery Pond and delivered to townspeople until the early 1900s. Jim Remington (left) and Charles Sweet are seated in the wagon.

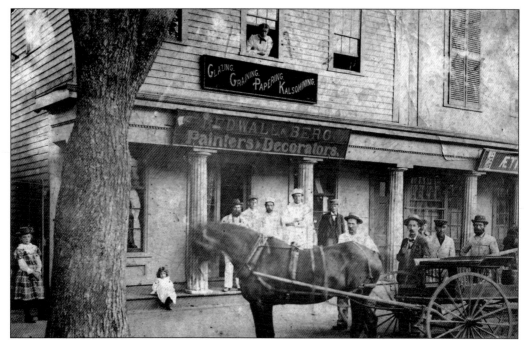

ARCADE ON MAIN STREET. This first section stood next to the old town hall (1886–1964). Main Street was mud most of the time until 1900. Stones were taken from what is now Eldredge School field, crushed, and used to macadamize Main Street. It was the first paved road in town.

NO. 30 MAIN STREET. This house can be traced back to when Emily S. Chace bought a lot with a building thereon on November 1, 1891, for $2,000 from Silas Weaver II (1802–1896). A handwritten scroll in the cellar bears the date of 1849. The property has passed through many owners, one of which was the Bethesda Circle of the King's Daughters in 1912–1913, an international Christian association still in existence. The house has been owned by the Caluori family since 1928.

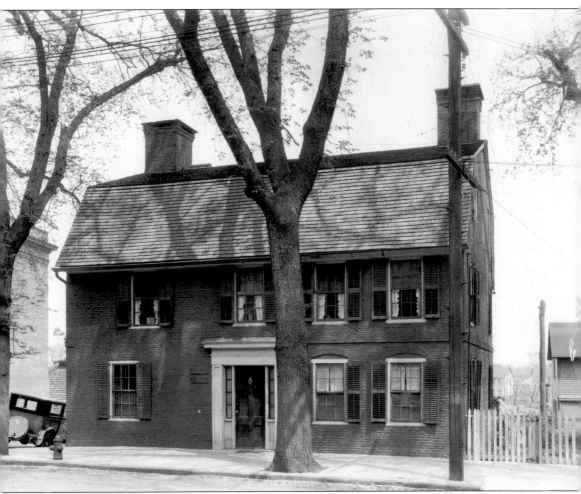

THE COLONEL MICAH WHITMARSH HOUSE, BUILT AROUND 1767. Also known as the Brick House, this building is at 294 Main Street on the southeast corner of Main and Long Streets. Built by John Reynolds for his own use, it is the first brick house (old English brick) and the first appearance of Georgian architecture in the town. The gambrel roof house is four bays wide with a small ell addition in the rear. There is one central entrance with a simple Greek Revival frame, probably installed about 1840. There are large brick chimneys at each end. In 1771, John Reynolds sold the property to Stephen DeBlois for use by a prominent Newport merchant, Aaron Lopez, as a branch trading post. In 1773, Micah Whitmarsh bought it for his residence. Whitmarsh was a colonel in the Kentish Guards and served under Gen. George Washington in Varnum's Brigade during the hard winter at Valley Forge. Today it is listed on the National Register of Historic Places. (Stevens photograph.)

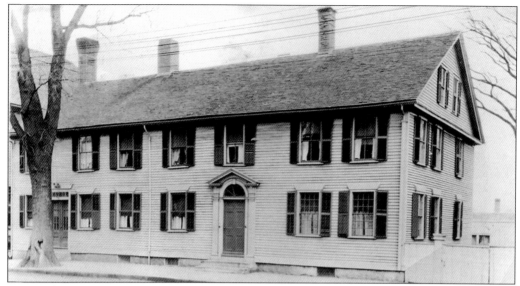

THE FIRST RHODE ISLAND CENTRAL BANK. The Rhode Island Central Bank operated from 1805 to 1840 in this building, known as the Capt. Benjamin Greene house, located on the east side of Main Street between Division and King Streets. In the cellar was a four-foot-square bank vault made of stone with a massive iron trapdoor. This bank was recognized as the second bank established in Rhode Island. The first bank president, Ethan Clarke, arrived from Newport in 1802 and purchased the General Varnum House on Peirce Street for his home. This building, built in 1759, was razed in 1938. (Stevens photograph.)

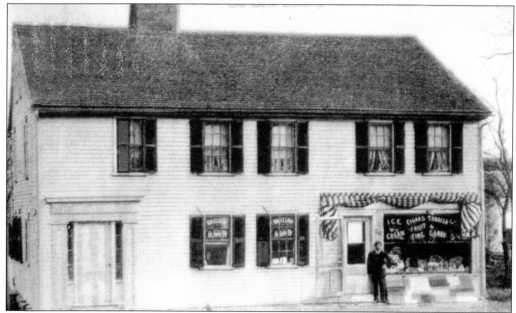

THE SECOND RHODE ISLAND CENTRAL BANK. Where the Varnum Memorial Armory (built in 1914) now stands on the northeast corner of Main and Division Streets, the second Rhode Island Central Bank once stood (1840–1855). The banking firm then moved to 267 Main Street where it came to an end after an existence of 52 years of service. This building was razed in 1913.

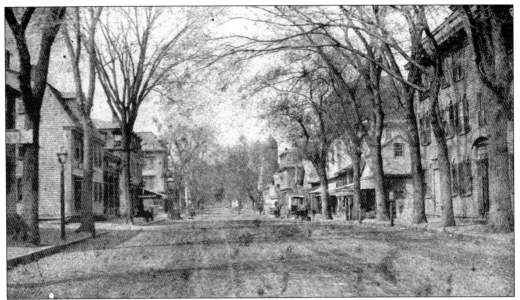

MAIN STREET, LOOKING NORTH, C. 1888. On the left, at the foot of Church Street in the Bodfish Block, stands a men's clothing and tailoring shop. On the right is the old Updike Inn (now the Greenwich Hotel), Sharpe's Hardware, the Browning Block, the Arcade, and the old town hall.

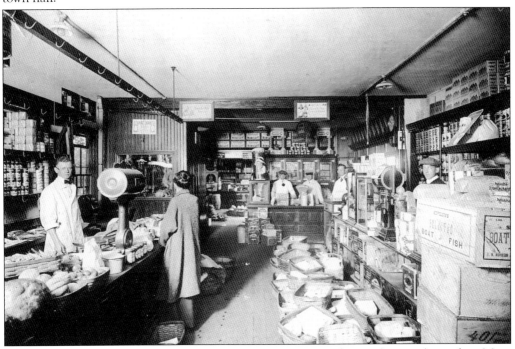

MUNSON'S GROCERY STORE, MAIN STREET, EARLY 1900S. This market was located on Main Street between London and Long Streets. A parking lot fills the space now. Notice the grocery orders on the floor. In the early days, groceries were delivered about the town. It is estimated that there might have been over 20 such markets in downtown East Greenwich servicing the different areas.

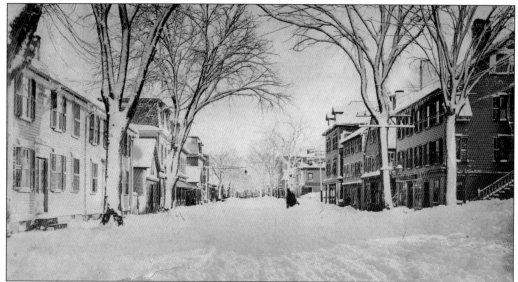

SILENT NIGHT! This is a tranquil winter scene of Main Street about 1900, taken looking south from Montrose Street.

EBENEZER SLOCUM HOUSE, EARLY 1800S. This structure, now razed, once stood on Mascachaug Hill, Main Street, at the south end of town. For the curious, the sign attached to the house, which bore no date, read, "George Washington never slept at this house but Apco Shock Absorbers are made in Providence fifteen miles from here." Ebenezer Slocum died August 12, 1887, in his 73rd year and is buried in the East Greenwich Cemetery No. 3. (H. W. Reynolds photograph.)

THE UNION BLOCK. These mill houses, nine in all, running along Main Street and up Greene Street, were rented to the Union Mill and Drysalters workers. The houses were torn down in 1954 to make way for a new shopping center. (Gunderson photograph.)

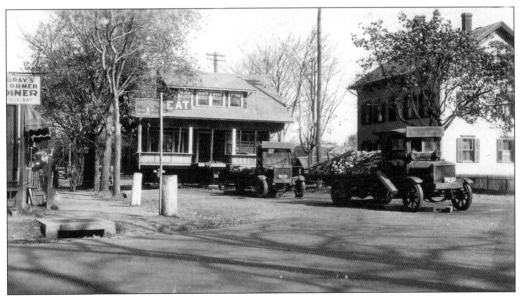

ON THE MOVE! This house being towed south along Main Street around 1920 now rests at the corner of Main Street and Fifth Avenue. Gray's Diner, the sign on the left, once stood on the corner of Main Street and First Avenue.

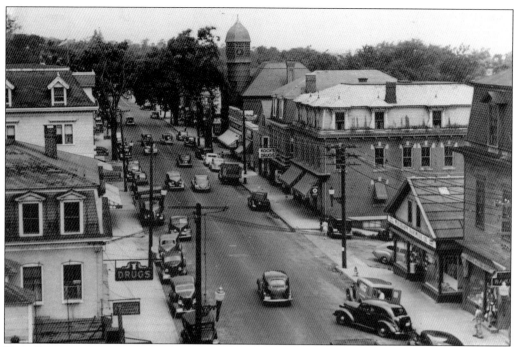

VIEW LOOKING NORTH UP MAIN STREET. In this picture, taken around 1945 from the third floor of the Masonic building, are shown several buildings still standing today and one no longer there. At the extreme right, the large building with the mansard roof is seen burning in the picture on page 21. There has been no building on that lot since the fire. (Gunderson photograph.)

THE COOK-LAWTON HOUSE. This house once stood adjacent to the Methodist church on Main Street. Patience B. Cook (1803–1890) and her grandniece Phebe I. Lawton (1850–1900) owned this 10,000-square-foot lot and large residence. In 1922, it was purchased by the Union Trust Company. The bank razed this house in 1924 and built a one-story brick building of Colonial architecture. Bank of America resides there now.

THE MCCLURE HOUSE. The W. J. McClure Print Shop, Miss Griffin's Hat Shop, and the fire station in 1922 are seen here. In the foreground a gas pump sign advertises Bessemer gas at 26¢ a gallon at Toohey's Garage, a harness shop on Main Street at Dedford Street.

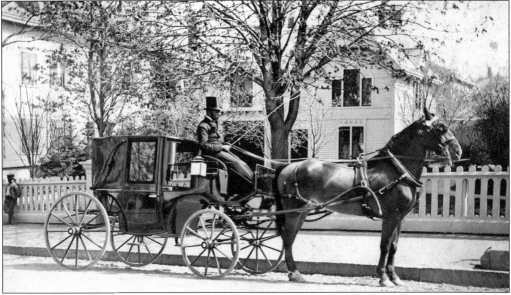

WHEN LIFE WAS GRAND! Charles T. Algren, former state senator from East Greenwich, recalled the lifestyle of the Goddards, the Russells, and the Gammells of Potowomut: "Wonderful places over there. They all had horses, coachmen and a footman. They used to drive down to town every morning to the train. They'd take the train to Providence and then be picked up at night again and brought home. It was a wonderful sight to see those horses driving down the street at night. Beautiful." From *East Greenwich, R. I., 300 Years, the Tercentenary Book, 1677–1977*.

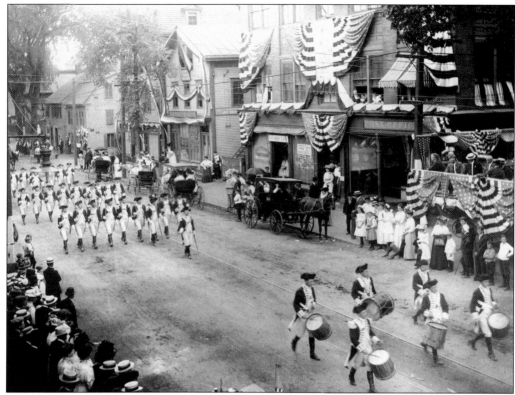

FOURTH OF JULY PARADE, 1908. Visible in the above picture are the newly organized Varnum Continentals (1907) in their new uniforms, marching north on Main Street. The reviewing stand is at right. Adjacent to the reviewers is the Masonic building (1893) at the corner of Main and Church Streets, housing the U.S. post office. Prior to 1928, everyone had to go there to pick up their mail.

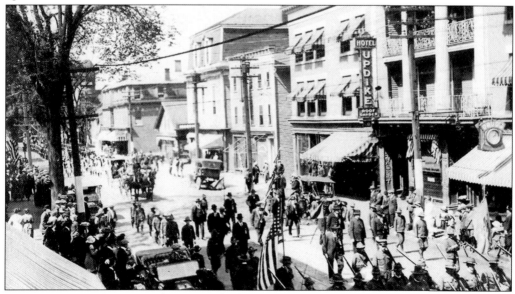

AN EARLY-1900S PARADE. This view is looking north from the Armory Street corner.

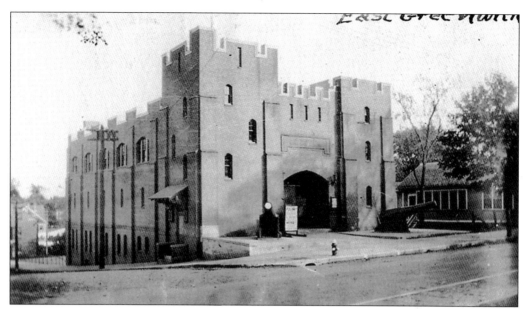

VARNUM MEMORIAL ARMORY AND MILITARY MUSEUM, 6 MAIN STREET. Built in 1913 by the Varnum Continentals, it is a memorial to Gen. James Mitchell Varnum. The Varnum Continentals are a patriotic, social, and military organization to perpetuate the customs, uniform, and traditions of the American Revolution. The lower level of the armory houses a historical museum. This photograph dates back before World War II. The so-called Rodman cannons were removed at that time to be used for scrap.

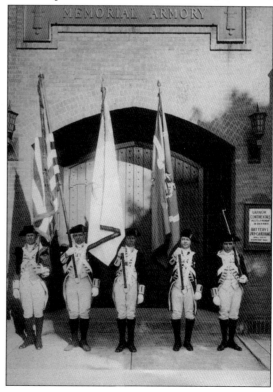

STANDING AT ATTENTION. These are members of the Varnum Continentals in front of their armory. In the picture are, from left to right, Charles H. Balfour, A. Morris Earnshaw, Emil Wellen, Orrin E. MacCue, and Harry Nichols. (Stevens photograph.)

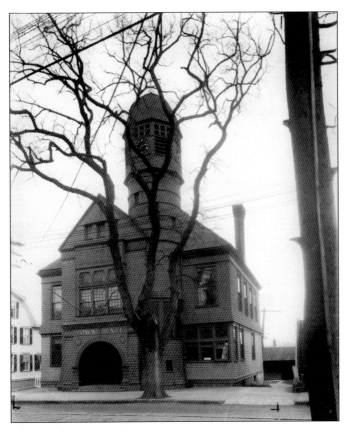

OLD TOWN HALL, 70 MAIN STREET, 1886–1964. This building was considered one of the finest examples of Queen Anne–style architecture. The building committee was William Browning, Wanton Shippee, Thomas N. Fry, Samuel M. Knowles, and Thomas A. Reynolds. A lot was purchased for $2,000 from the estate of Sarah P. Greene, upon which the town hall with a 70-foot tower was built at a cost of $8,000. The tower clock was donated by Mary M. Sherman in memory of her husband, William Northup Sherman, who owned the local newspaper. In 1964, the handsome two-story building was razed. Today it is a public parking lot. (Stevens photograph.)

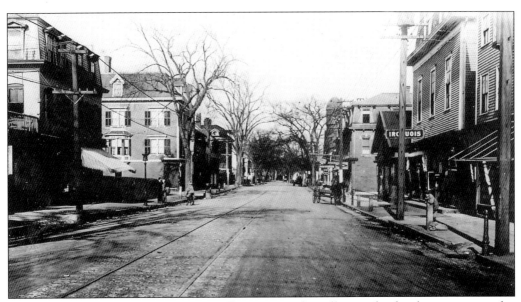

LOOKING NORTH ON MAIN STREET. The times with trolley tracks, hitching posts, and a horse-drawn wagon are past. The street on the left is Court Street (now Court House Lane). On the right, just past the wagon, is King Street with the Browning Block on the corner.

Four
THE HILL

The third hill of East Greenwich rising up from the harbor offers magnificent views of Narragansett Bay and the islands. It ascends steeply from Main Street to Peirce Street.

Dr. Daniel Howland Greene, a physician practicing in East Greenwich at the time of the Civil War, writes in his book of 1877, "Very few places in New England possess advantages equal to East Greenwich. Its climate is mild and remarkably healthy, owing to its location, the village being built on the side of a lofty hill, facing the southeast, protected from the cold north and west winds by still more high grounds in the interior."

On this hill was erected in 1802 the academic institution of learning known through its 140 years as Kent Academy, Providence Conference Seminary and Musical Institute, and, lastly, as the East Greenwich Academy. It encompassed on its five acres the brick main administration building, the Boarding Hall (later Eastman Dormitory for Girls), Winsor Hall, Olney Cottage, Clarke Cottage, and Swift Gymnasium. The headmaster's residence, Rose Cottage, was on the opposite side of Peirce Street.

Surrounding this famous boarding school, spacious dwellings sprang up, and a new neighborhood, the Hill, was formed—with imposing mansions of the wealthy shaded by fine elm trees—in the pursuit of the rich life of the Victorian Age.

In the latter half of the 19th century, there began a great exodus from Sweden, as many as 37,000 in the 1880s. In 1872, Carl F. Anderson came to East Greenwich. He and his wife Sophie settled in the little house just behind today's Boy Scout Hall on Spring Street. They cared for the immigrants arriving daily from the old country to start life anew. The Swedes felt strongly the ties of nationality and settled in numbers in the hill area bounded by Church, West, Division and Peirce Streets. The townspeople jokingly called this part of town "Swede Hill."

Besides the two churches that still remain on Peirce Street, the First Baptist Church and St. Luke's Episcopal Church, there once stood the Friends Meeting House (1804) just south of the academy property. Unfortunately, this Quaker house and the East Greenwich Academy were demolished in the 1960s. They represent some of the most important buildings of the early Republican period (1780–1810), and their loss is a major gap in the historic downtown area.

The East Greenwich Historic District was entered in June 1974 on the National Register of Historic Places (Act of 1966). On the Hill remain many structures, sites, and areas significant in American history, architecture, archeology, and culture.

RECTOR STREET, FACING DIVISION STREET. The photograph was taken before 1920 when the streets were still unpaved. The tall house on the left corner is still there, except it has been moved westerly and the stone wall is gone. On the right, what is now a family residence was the Swedish Evangelical Covenant Church. Built in 1895, it had a faithful congregation and a fine Sunday school for over 60 years.

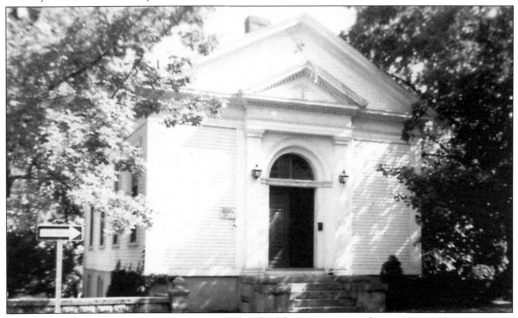

THE EAST GREENWICH FREE LIBRARY. This building was erected in 1870 at the corner of Montrose and Peirce (then Elm) Streets. The library corporation was organized in 1867; the first library was a room rented on Main Street. This building served the town until 1915. In 1922, it was purchased by the Royal Arcanum Society, a fraternal life insurance business. In 1930, it was bought by the First Baptist Church for a parish hall and Sunday school. In 1955, it was demolished and replaced by the present church house.

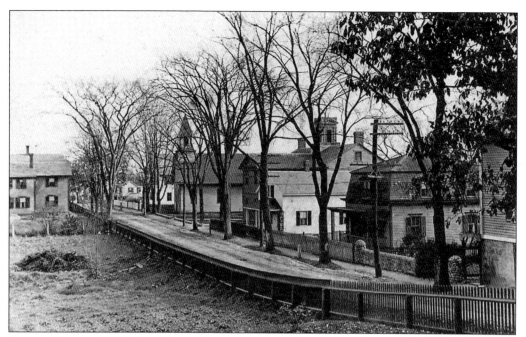

SPRING STREET, 1908. Note the picket fence surrounding the academy property and the stately elms. The building with the steeple was where the Swedish immigrants worshiped from 1874 until 1894. It is now the Boy Scout Hall. In the distance on the right rises the old Providence Drysalter's Mill, built around 1836.

DR. PETER TURNER HOUSE, 21 COURT HOUSE LANE, BUILT AROUND 1774. This house was built within a five-acre oak grove that Dr. Peter Turner owned surrounding Marion Street. In 1776, he married Elizabeth Child, the sister of Gen. James M. Varnum's wife. Turner served as a surgeon with Gen. Nathanael Greene's forces during the Revolutionary War. He died in 1822 and is buried in his oak grove. (Stevens photograph.)

THE BOWEN HOUSE, PEIRCE STREET, BUILT AROUND 1830. This view is from the side along Revolution Street. William Gorton Bowen (1799–1854) was a lawyer of "unblemished reputation." The park at the top of Court House Lane was made by his son Dr. William Shaw Bowen in 1894 to fulfill a wish of his father.

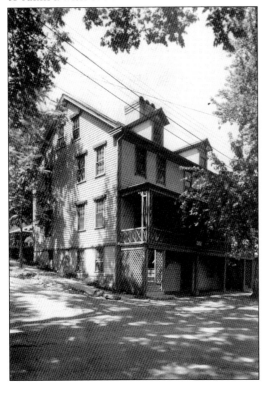

THE OLIVER WICKES HOUSE, BUILT AROUND 1785. This early Republican–style house is at the corner of Melrose and Peirce Streets. Oliver Wickes is perhaps the best known of the house carpenters of the town. The Kent County Court House (now the town hall) was built in 1804 with Oliver Wickes as carpenter. It is said that the paneling in the southeast room of the Wickes House came from the old courthouse when the new one was built in 1804.

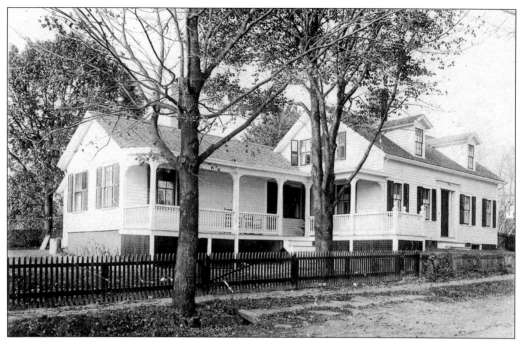

THE MAWNEY HOUSE, BUILT AROUND 1835. This Greek Revival was the first house on Mawney Street. The name Mawney is the Anglican version of LeMoine. Moise LeMoine was one of the Huguenots who settled the Frenchtown area in western East Greenwich in 1686.

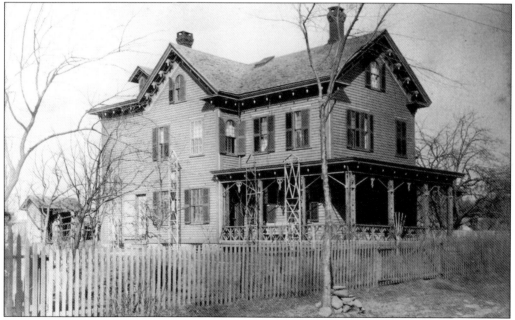

BENJAMIN B. SPENCER HOUSE, BUILT AROUND 1875. This house is located at 51 Mawney Street. The Spencer name dates back to 1677 when the first John Spencer arrived in East Greenwich from Newport with his wife Susannah and their six sons. John Spencer is the first named among the 50 original proprietors of this township. The above house was built by one of his descendants, and until recently, Spencers have occupied this house. (Gardiner collection.)

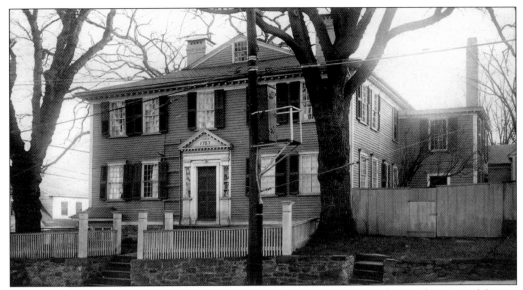

ELDREDGE HOUSE, 28 DIVISION STREET, BUILT AROUND 1774. This is the second house in town linked to the innovative builder John Reynolds. A two-story central hall Georgian structure, it embodies all the ideals associated with the Italian Renaissance. An interesting note is that the house is built on the site of the first tannery in town. In 1810, Dr. Charles Eldredge arrived to fill in for a Dr. Tibbitts. He did not intend to stay permanently but found himself becoming attached to the town and remained until he died in 1838. Eldredge is known as a founder and charter member of the Rhode Island Medical Society.

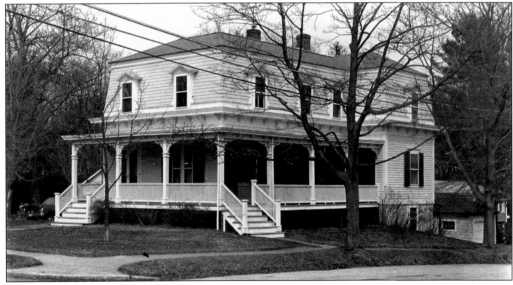

DANIEL POTTER BURDICK HOUSE, BUILT AROUND 1885, CHURCH STREET. Daniel Potter Burdick, a native son of East Greenwich, was born July 21, 1853, and married Annie E. Budlong in 1881. He was employed as an overseer at the American Screw Company in Providence, and later as an insurance agent. The Burdicks lived here 14 years, selling the house to Emerson Almon Gould and Marion Ida Keyes Gould, proprietor of a grocery business and civic leader. At his death on July 19, 1929, his daughter, Julia Stacy Gould, a singing teacher, inherited this French-roofed cottage. The house has had two owners in the past 24 years. (Pendulum photograph.)

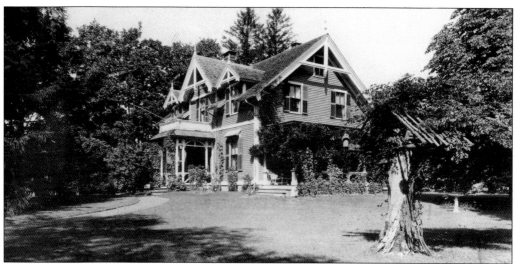

HILLTOP COTTAGE. From a direct descendant, Thomas Casey Greene, comes the history of this beautiful mansion situated facing Church Street between Brayton and West Streets. "Built in 1874 by my great-grandfather, a lawyer also named Thomas Casey Greene, as a summer place. Originally a Victorian fence bordered the property with two arched gates. My great-grandfather died in 1896. His wife Margaret Cushing Ladd Greene survived him by 14 years. Their son Samuel Ward Greene inherited the family home. However, he was crippled as a child and preferred to stay on lower Spring Street in a tent-like structure. Samuel died in 1938. My aunt, Kitty Greene, moved to Hilltop Cottage that same year and stayed until her death in 1970." (Earnshaw photograph.)

MILLER-CONGDON HOUSE, 20 DIVISION STREET. This house is situated on the corner of Peirce Street facing Division Street. The year 1711 is on the chimney and architectural features of the interior seem to bear out this date. But the date 1750 is also firm. Record searching has unearthed little to settle the dispute. In the early part of the 19th century, James Miller lived and ran a silversmith shop at the rear. A lovely, rambling old home, it laid out like many houses of the early 1700s with a large fireplace in the living room with iron cranes, pots, and wooden peelers. In the 1850s, the house was purchased by Capt. John Congdon, a sea captain and trader.

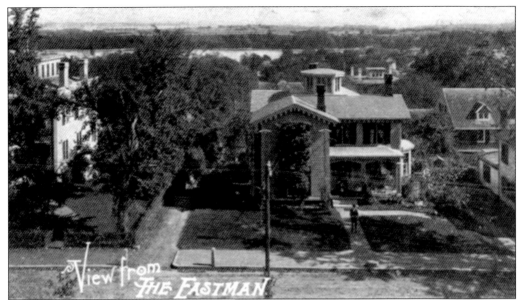

ROSE COTTAGE AT 112 PEIRCE STREET. Called the Rose Cottage because of the beautiful climbing roses in the summer, this house is situated across the street from the site of the East Greenwich Academy's Boarding Hall. This early-Victorian, two-story house, built around 1850, was purchased by the school in 1888 to serve as the headmaster's residence because of its "elegant parlors for social life." In 1943, it was sold, and today it is a private residence. (MacGunnigle collection.)

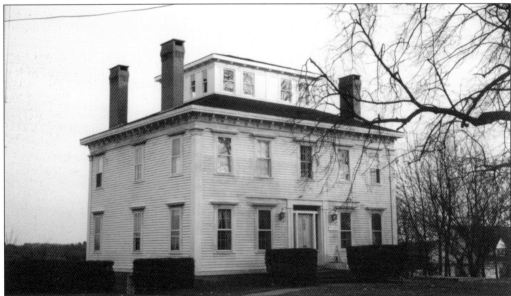

THE KNOWLES HOUSE, BUILT AROUND 1851, 100 PEIRCE STREET. This large white clapboard house has eight large rooms on two floors built around a spiral staircase that climbs from the ground floor up three floors to the lantern, a structure built on the rooftop with open or windowed walls. Originally there was a curved portico on the front of the house and a wrought iron fence surrounded the front yard, which was graced by stately elm trees. It is currently owned by the Kentish Guards. (E. G. Chamber photograph.)

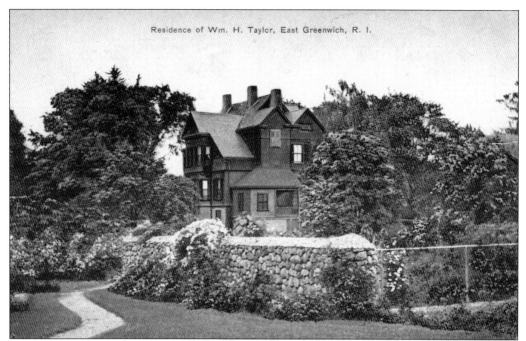

No. 41 Marion Street. Two 1913 postcards picture the expansive, beautiful piece of property on Marion Street running through to Rector Street. The house at 41 Marion Street, built at the beginning of the 20th century, was owned from 1912 to 1921 by William H. Taylor and Fannie Taylor (née Brown). William H. Taylor dealt in watch and optical findings in Providence with his brother George. In 1921, the house was sold to William C. and Grace Huntoon, who owned it until 1935. Despite the number of owners before and after, it has long been called the Huntoon house. (Above, William A. Browning; below, E. F. Henry.)

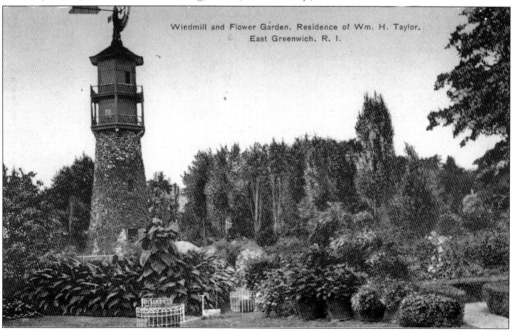

HOME OF DANIEL ALBERT PEIRCE, SPENCER AVENUE. This building was built just over the town line in Warwick after Daniel Albert Peirce gave the house and property he grew up in on Peirce Street to the East Greenwich Free Library Association as the site for its new library in 1913.

DANIEL ALBERT PEIRCE, 1838–1932. Daniel Albert Peirce was a descendant of Giles Peirce, one of the original founders of the Town of East Greenwich. In 1913, he, a trustee and treasurer of the library association, announced to the trustees that he wished to erect a new library, equip it, endow it, and present it to the association. The present handsome free library at Peirce, Church, and Armory Streets, dedicated June 29, 1915, is built on the site of Peirce's boyhood home. The library is a memorial to his adored daughter, Adeline Vaughn Peirce, who died as a young child.

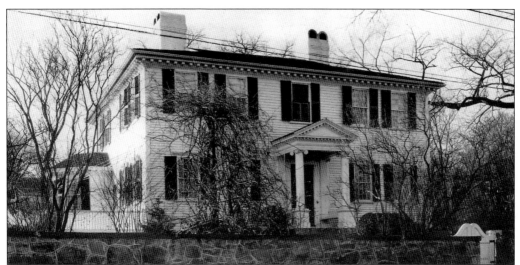

THE VARNUM HOUSE, 57 PEIRCE STREET. In 1773, Gen. James Mitchell Varnum bought land on Peirce Street from John Peirce for about $90, which included the lot in back of the courthouse. A Georgian-style house was built by John Reynolds, an early builder. Gen. Marie-Joseph-Paul-Yves-Roch-Gilbert du Motier, Marquis de Lafayette and Gen. John Sullivan were frequent visitors. In 1778, when Varnum went to Ohio, he sold the house and land to John Reynolds. Eventually it was purchased by Ethan Clarke, one of the founders of the Kent Academy, and was occupied by his descendants until 1922. In 1939, it was sold to the Varnum Continentals for a historical museum. It is on the National Register of Historic Places.

ST. LUKE'S PARISH HOUSE, PEIRCE STREET. As early as 1888, the St. Luke's congregation needed a meeting place. Funds were raised for eight years, and in 1896, this first parish house of late Victorian style situated diagonally across Peirce and Church Streets was erected. It was sold in 1962 for use by the University of Rhode Island Cooperative Extension Service. Recently it was sold for a private residence. (E. F. Henry postcard, EGRI.)

KENTISH GUARDS ARMORY, PEIRCE STREET. Built in 1843 at corner of Armory Street, just after the Dorr War of 1842, the armory is home to the Kentish Guards, the fifth-oldest chartered command in continuous existence in the United States, chartered in 1774. Little has been done over the years to change their building, considered "a superb Greek revival temple type architecture." (Greene Chapter, DAR.)

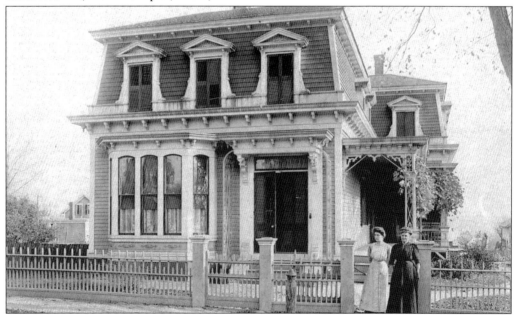

KENYON-HUNT-HENRY HOUSE, 51 MAWNEY STREET. Between 1875 and 1885, Henry Hunt and his mother, Eliza, purchased three lots and built this large two-family Victorian house and barn. In 1910, it was purchased by Frank B. Henry and his sister Edith M. Henry. In 1914, Frank B. Henry married Ethel R. Congdon, and they raised three children, Roberta, Thaire, and William, there. In front of the house are Edith B. Henry and her mother, Eva B. Henry. (Henry collection.)

Five

FRENCHTOWN AND THE OUTSKIRTS

By today's topography, a rough estimate of the boundaries of the Huguenot settlement would be South County Trail to Frenchtown Road, to the West Greenwich line, then to the Exeter line. The Huguenots, or puritans of France, were French Calvinists who, in 1685, after the repeal of the Edict of Nantes by King Louis XIV, feared for their lives and fled to England, Holland, Geneva, Brandenburgh, and America. These people were not of the poorer or ignorant classes of society; they were considered the flower of France—wealthy, intelligent, and enterprising—and were gladly welcomed by the nations to which they fled. Although their stay was short-lived (1686–1691), the culture of the Huguenots did leave a mark on the town of East Greenwich, and the locality of their brief settlement will be forever known as Frenchtown.

Some of the French settlers did remain. It is believed Dr. Pierre Ayrault moved into the village and practiced his profession for a time. A sign was erected by the state of Rhode Island in 1933, indicating the Huguenot settlement in 1686, but this was removed when Route 4 was built.

In 1943, the U. S. Navy took approximately 6,680 privately owned acres of land in four Kent and Washington County towns: East Greenwich, West Greenwich, Exeter, and North Kingstown. Thirty owners in East Greenwich had used much of this land for agricultural and dairy purposes. Some of the farms and people forced to move from their land were Edwin T. and Rosalind (Rose) Arnold and daughter Grace Arnold, located on South Road west of Route 2. Winfield Scott Shearman and Martha Shearman (née Fink) and daughters Elsie and Edna and son Clifford. From the early 1900s, their land extended from Route 2 to Tillinghast Road. Maps of 1862–1871 list the farm as belonging to A. T. Mawney. Harry and Clara Wheeler, son Clarence and Edith Wheeler, and family (north of the Shearman farm on Route 2) lived in a two-story house with porch across the front. There was a large barn where they kept cows and produced milk. All the farm buildings were destroyed and the Navy Seabees practice range was made there. The Wheelers moved to a farm in Hope Valley that is now the Fenner Hill Golf Course. William Tillinghast and Evelyn Tillinghast (née Rathbun) held an auction March 19, 1943, on their Tillinghast Road farm south of Frenchtown Road. They sold all their animals, farm tools, and machinery and moved to Coventry. Earle E. Tarbox and Louise Tarbox (née Nichols) and his parents, Fones W. Tarbox and Ada Tarbox (née Matteson) vacated homes and farm on the western end of South Road. Other acreage was taken from Harry C. Vaughn and E. May Vaughn (née Andrews), Lois A. and Alice Sumner, Leonard Weindel, Cecil Ferguson, Sarah Lemner, George I. Kenyon, Edgar J. Hathaway, Cloyde Desgranges, Rhodes A. Cook, among others.

On July 8, 1943, the Frenchtown Community Club House on Route 2 was turned over to USO Club for navy men's relaxation and recreation from duty at the new artillery range. Part of this area is still Camp Fogarty Rifle Range.

Frenchtown Huguenot Plat – 1686

West lots	East lots (Est)	
Wm. Barbut	Est Bertin dit Laronde	
Paul Collin	Menardeau	
Jean Germon	Galay	
Dechamps	Ratier	Meadow Ground
Fougere	David	
Grignon	Beauchamps	
Legare	Moize le Brun	
Robineau		

The Great Road that leads between the Home Lots that leads to the Great Plains on the way to Boston.

West of river	East of river	East home lots
Peter Ayrault	La terre por l'Eglise	
Magni Junior	La terre por L'ecolle	
Magni Senior	Le Breton	
David Junior	Le Vigne	
David Senior	Tauexxier	
Chadene	Bouniot	
Foretier	Lemoine	
Ezechial Carré Ministre	Abram Tourtellot	
Louis Alaire	La Veue Galay	The Great Lots belonging to the Home Lots. Sud
Jamain	Targé Junior	
Russereau	Targé Senior	
Amian	Arnaud	
Lefon	Lambert	
Belhair	Rambert	
Milard	Coudret	
Jouet	Jean Julien	
Renaud		
Grasilier		
Le gendre	Ouest	

The Great River running to the Est. The Great Road running by the river into the Woods.

MAP OF FRENCHTOWN AREA. Several French settlers decided to not abandon their land. The LeMoines (Money, Mawney) held their land in Frenchtown for generations. Dr. Pierre (Peter) Ayrault remained, and his descendants married into well-known Rhode Island families. A descendant of the original family of Targé, Dr. Eben Tourgee, taught music in the 1860s at the Providence Conference Seminary and Musical Institute (later the East Greenwich Academy). In 1867, Tourgee founded the New England Conservatory of Music in Boston. East Greenwich has an Ayrault Road, a Mawney Street, and an Ezekiel Carré Drive named in their honor.

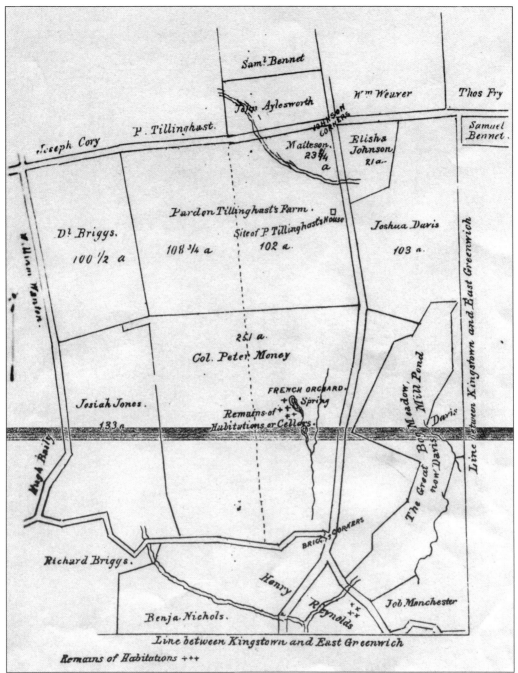

LAYOUT OF THE FRENCHTOWN HUGUENOT FLAT IN 1686. Under their minister, Ezekiel Carré, the Huguenots built homes, a meetinghouse, and a mill to grind grain; they cleared meadows and planted orchards of apples, grapes, honey locusts, and a mulberry preserve to produce silk. However, the Huguenots were beset with problems of language, misunderstandings, and legal entanglements and were the victims of land speculation, namely, the Atherton Land Purchase. Disheartened, most of them abandoned their homes in 1691 to join other settlements in New York and Massachusetts.

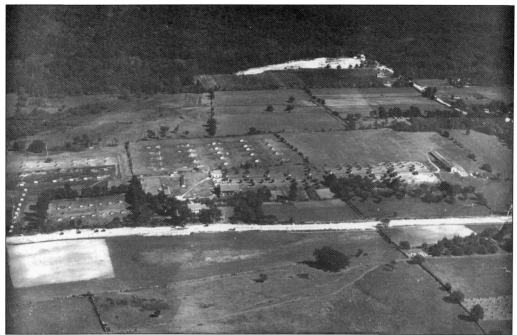

BIRD'S-EYE VIEW. This picture looks east over Route 2 and Lewis Farms around 1923. This photograph was taken by the Curtis-Wright Aviation-Photograph Division. (Lewis collection.)

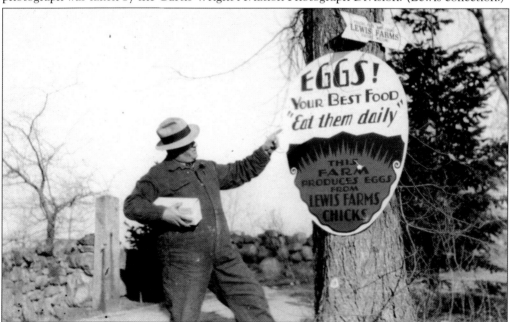

LEWIS FARMS. Prof. Harry R. Lewis retired from teaching poultry husbandry at Rutgers University in 1921 and established a poultry plant on South County Trail (Route 2) and Frenchtown Road. His wife's family had owned the 108-acre farm for seven generations. Here Lewis mass-produced standard breed poultry, including white leghorns, barred Plymouth Rocks, white wyandottes, and Rhode Island Reds. The 1938 hurricane destroyed much of the farm, and it was never rebuilt for poultry. Instead, Lewis turned to housing development of the area. (Lewis collection.)

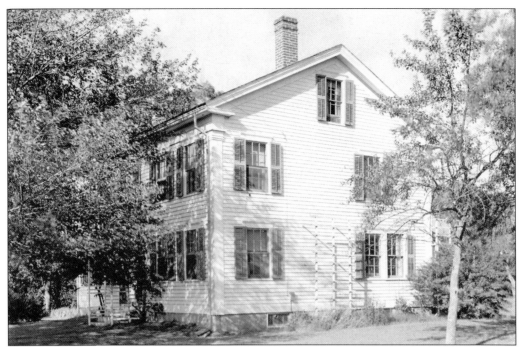

AYRAULT ROAD. This imposing house is located in the area called Frenchtown at Ayrault Road and Route 2. On a map dated 1716, the land appears with the name Joshua Davis. However, at the time the house was built, around 1840, the names Mumford P. Tillinghast (1803–1875) and wife Clarissa Tibbitts Tillinghast (1803–1901) appear on maps dated 1863 and 1871. Their cemetery No. 32 is located nearby. (Stevens photograph.)

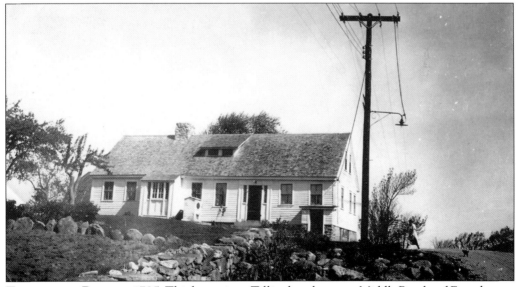

TILLINGHAST ROAD, C. 1785. This house is on Tillinghast between Middle Road and Frenchtown Road. In 1716, the 130-acre farm was owned by George Vaughn. A map dated 1862 shows the farm was then owned by Thomas Tillinghast. At the time the Tillinghast Mill was operating, from 1814 to the 1870s, a post office was located here. The house is still there, but today new large houses stand on most of the original farmland.

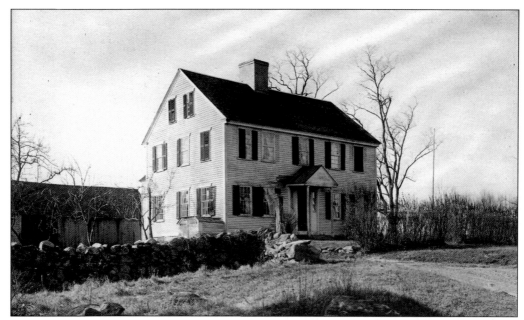

THE WEAVER-MAWNEY HOUSE, BUILT AROUND 1750. Styled after early-Republican architecture, this house still stands at 650 Cedar Avenue. It was known as the Weaver family home and later as the John O. Mawney house (around 1860). The Weavers date back to 1677 as one of the early settlers given a land grant by King Charles II of England. Mawney (anglicized form of LeMoine) was one of the Huguenots who settled here in 1686.

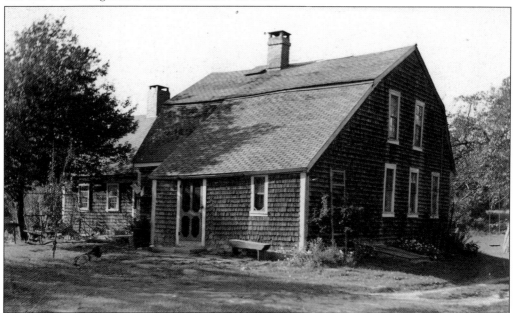

THE BOWEN SPENCER HOUSE. Often unnoticed as it sits secluded on the left side of Middle Road just west of Route 2, the original house was built in 1715 on a 112-acre farm. Later, in 1753 and again in 1755, Wilson Spencer put on additions. Generations of the Spencer family occupied this place for almost 150 years. William Bowen Spencer died in 1910. The family burial ground, No. 56, dating back to 1772 is situated west of the house. (Stevens photograph.)

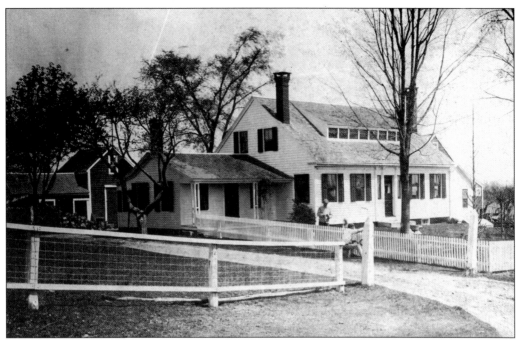

PLACE FARM. This tidy farmhouse has rested at the crossroads of Frenchtown Road and Tillinghast Road since 1830. Descendants of Arba J. Place and his wife, Betsey Johnson Place, occupied and worked this farm through the 1950s.

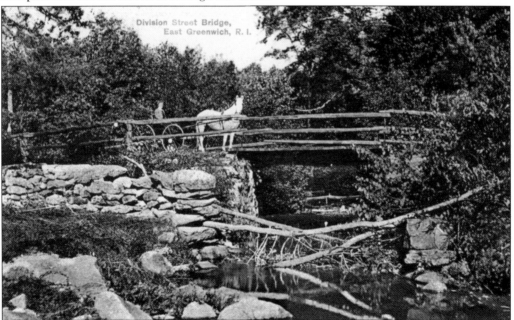

DANCING BRIDGE, DIVISION STREET. Dr. James H. Eldredge (1816–1892), in his recollections of East Greenwich, describes the impassable bog at the foot of the hill on Division Street, west of Love Lane. A road was eventually built over the bog (around 1799) by laying down brush and then gravel. A bridge was later built on this foundation. Even an ordinary carriage would cause both the bridge and roadway to tremble, hence the name, Dancing Bridge.

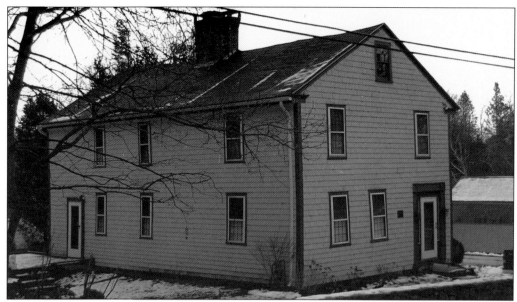

LONG-LANGFORD-KENYON HOUSE, 441 CEDAR AVENUE, BUILT AROUND 1716. Its original Colonial design was altered sometime later to Greek Revival, moving the entrance with sidelights and pilasters to the gable end. Yeoman Philip Long was granted land for his services during the King Philip War of 1675–1676; John Langford, yeoman, was his grandson. Thomas Elwood Kenyon purchased the 30 acres in 1840. It remained in the Kenyon family until 1930. (Clarke photograph.)

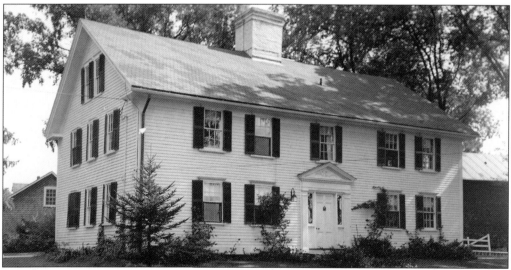

CROSSWAYS FARM. Christopher Spencer built this central chimney Colonial farmhouse in 1772 at the corner of Middle Road and Cedar Avenue. In 1835, Lodowick Updike Shippee purchased this "white house" from the estate of William Greene Spencer. It became known at that time as Crossways Farm. The original property was a sizeable 175 acres, bounded in whole or in part by four roads—Cedar Avenue, Middle, South Pierce, and Post Roads. Under the ownership of Jesse Wanton Shippee Lillibridge, who was the great-grandson of Lodowick Shippee, Crossways Farm supported lane herds of purebred Guernsey cattle. Since the early 1940s, the farm has undergone extensive development and is now the site of a school and many homes. (Stevens photograph.)

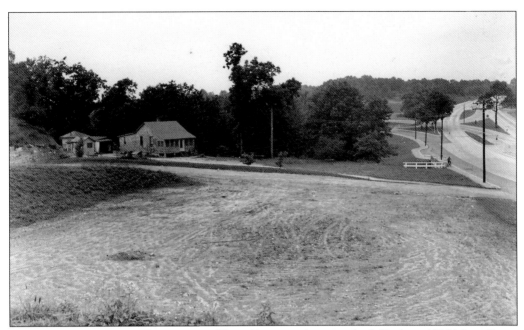

THE BLEACHERY HILL. The cottage of Peter Rice sat alone on the hillside at 1016 Main Street until 1962 when it was demolished. It is now the site of Local Post No. 15, American Legion. (Gunderson photograph.)

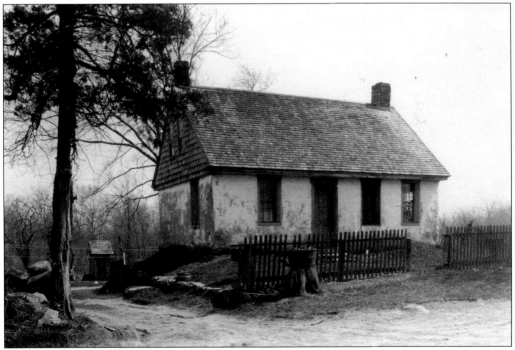

ALONG NICHOLS BROOK. Charles Eldredge Nichols is known to have lived here at 288 Middle Road although it was his father, Charles S. Nichols, who built this interesting stone house sometime between 1835 and 1870. The most recent owner was James H. Wilkinson. Note the privy.

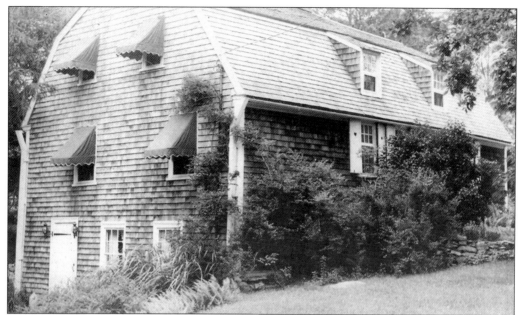

THE BROWNBREAD HOUSE. This lovely old Colonial Cape has been on Middle Road west of Route 2 since 1680, three years after the founding of East Greenwich. It was built by Caleb Spencer around a great chimney with seven flues, five fireplaces, and two beehive ovens. It is essentially the same throughout the three centuries, except for one addition. (Pendulum photograph.)

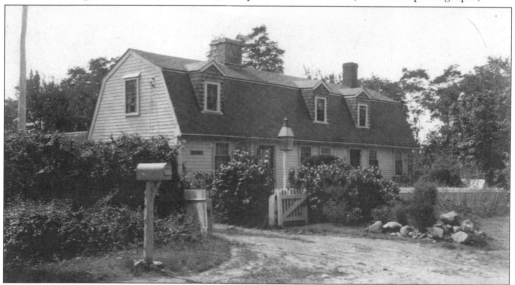

THE LILACS, BUILT AROUND 1715. This gambrel-roofed cottage is aptly named for the fragrant lilac bushes that grow abundantly on the property. It nestles at Nichols Corner, the junction of Middle Road and South Pierce Road. The well in the front yard was often used by farmers on their way to and from the waterfront to water their horses. In 1784, the Thomas Nichols lot became the property of Rufus Spencer. Legend has it that on Saturday nights when beans were cooked at the Spencer "Lilac Cottage," at the other house on upper Middle Road built by John Spencer, brown bread was baked. The Spencer families dined on alternate Saturday nights at "the Lilacs" and the "Brownbread House."

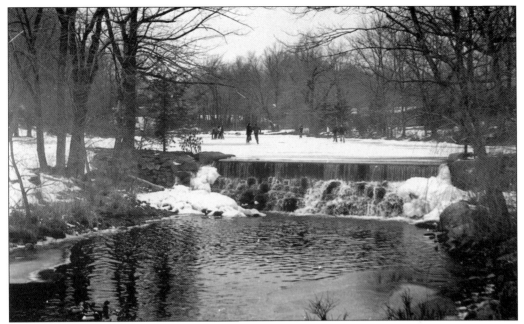

PAYNE'S POND ON KENYON AVENUE. The pond and its adjacent land was part of the original 90-acre parcel granted to first settler John Spencer (around 1677). It passed to his son Peleg and then to his grandson Jeremiah, who built a gristmill here. In some records, Jeremiah was called the "miller of Paradise Mill." Other names are Arnold's Mill, Spencer Mill, or as the old Friends Meeting House.

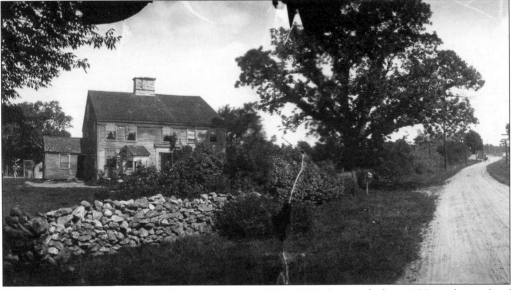

THE PELEG SPENCER HOUSE, BUILT AROUND 1710–1715. Located about 100 yards north of Payne's Pond on Kenyon Avenue was this remarkably sturdy old house, sometimes also known as the Payne House. Peleg was a son of John Spencer, a founding settler. Judith Spencer Payne, who died December 10, 1893, at 84 years, is buried in Cemetery No. 23 on Cedar Avenue. The house was razed in 1914. The land on the right of Kenyon Avenue is known as Paradise Park and was owned by the James F. Freeman Company. Lots were first offered for sale in 1909.

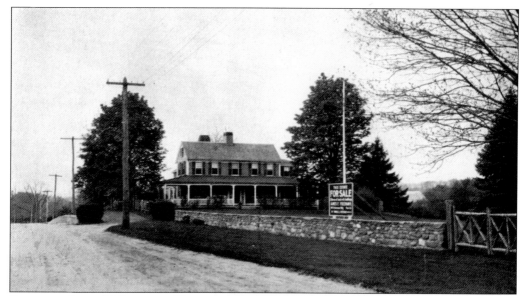

ESTATE OF JAMES F. FREEMAN, KENYON AVENUE. Originally this estate had 33 acres comprising houses, barns, garage, outbuildings, woodland, and running streams. This old Colonial house boasted a fine approach, an extensive piazza, beautiful lawns, and shrubbery.

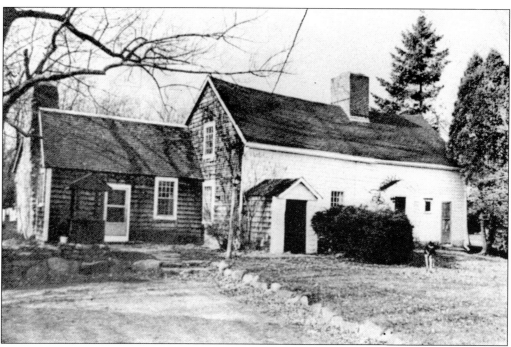

CLEMENT WEAVER HOUSE, 125 HOWLAND ROAD. This Colonial clapboard dwelling is the oldest house in Kent County, built in 1679 by Clement Weaver, one of the original grantees who received land when the town was founded in 1677. Starting with one room with loft above, the house has been added on to no less than four times. The Weaver family lived here until 1748. Then, purchased by Daniel Howland, a broker from Philadelphia and Portsmouth, it remained in the Howland family until 1940.

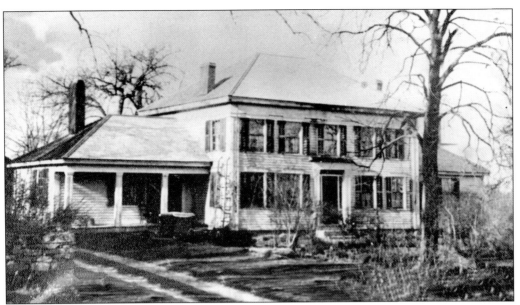

DANIEL BRIGGS HOUSE, NORTH SIDE OF DIVISION ROAD, BUILT AROUND 1840. In the early 1900s, Job Briggs (1829–1910) and his wife Esther "Aunt Mandy" Briggs (née Spencer) (1835–1929) resided here. E. Amanda Briggs, daughter of Deacon Richard Spencer and Roby Spencer (née Tarbox), compiled many records and helped people with their research of Rhode Island families. She assisted James N. Arnold with research for his *Vital Records of Kent County 1891*, the first of 21 volumes.

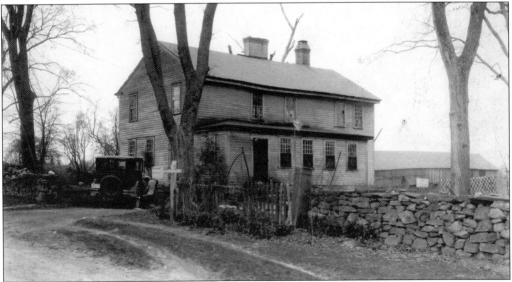

THE MAWNEY-ARNOLD FARM. This house and farm buildings were located west of Route 2 on the north side of South Road. Property was taken by the U.S. Navy in the 1940s for a Seabee training ground and eventually to become part of the Sun Valley Rifle Range. Residing there at the time were Edwin T. Arnold (1856–1951), his wife Rosalind (Rose) Arnold (1867–1938), daughter N. Grace, and son Joseph Ralph. A 21-grave cemetery on the property has granite posts and iron railings and is said to have been part of the Robert G. Mawney farm. Edwin's mother was Hannah Mawney Arnold.

NEW ENGLAND MUSEUM OF WIRELESS AND STEAM INC., 1300 FRENCHTOWN ROAD. Founded in 1964 by Robert and Nancy Merriam, curators, the New England Museum of Wireless and Steam Inc. buildings include the Massie Wireless Station, a National Register of Historic Places landmark, moved with original equipment from Point Judith; the Frenchtown Six Principle Baptist Meeting House, moved in 1972 from Frenchtown Road; Radio Science Hall; Engine Heritage Collection; and the Mayes Building. The museum is home to many antique steam engines, including the only working Corliss engine. The Merriams were honored with the 2005 Preservation, Education, and Advocacy Award by Preserve Rhode Island. (Illustration by Bonnie Zeck.)

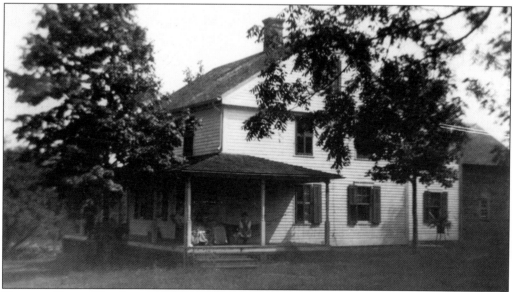

VAUGHN FARM. This house is located on Middle Road, west of Fry's Corner, Route 2, at the end of a long driftway (a private road to property not touching public highways) called Shady Lane. A stone in the chimney has the date 1752. On a 1716 map, this is the eastern part of Robert Vaughn's farm. On maps from 1863 to 1871, it is the property of Andrew G. Vaughn. (Stevens photograph.)

Six

ACADEMIA AND HOUSES OF WORSHIP

When the town was founded in 1677, children were either taught at home, apprenticed at an early age to local tradesmen, or attended what was commonly called a "dame school." Under the state law of 1828, public schoolhouses were required throughout the state.

Five district schools were erected in the town of East Greenwich. The school for District No. 1 was built between Duke and Exchange Streets. It was also used for a Baptist meetinghouse. The school for District No. 2 was held in an upper room of the Edmund Andrews house on Route 2. District No. 3 was a one-room schoolhouse on Shippeetown Road. In the 1850s, Union Baptists met in this school building. District No. 4 was the Tibbitts School located on the western part of Frenchtown Road. District No. 5, a Greek Revival one-room schoolhouse, still stands next to the Frenchtown Community Club House on Route 2 and is presently used by the Happy Hearts Learning Center.

As East Greenwich had no official high school until 1943, the town offered its local boys and girls the opportunity to attend high school at the East Greenwich Academy. The town paid the tuition.

The Baptists may be honored as the oldest religious body in continuous existence in East Greenwich. The founding fathers were Baptists. The Society of Friends, more commonly called Quakers, built its first meetinghouse in 1700 on John Spencer's land near Payne's Pond. In 1804, another meetinghouse was built on Peirce Street. St. Luke's Episcopal Church was organized in 1833. The Our Lady of Mercy Catholic Church traces its beginnings to the Irish immigrants of 1840–1850. In 1874, 41 persons of Swedish extraction met to form a Swedish Lutheran church. In 1943, by vote, the name was changed to First Evangelical Lutheran Church. Early Methodists met at the courthouse until 1831 when their first church building was erected at the corner of Main and Queen Streets. The Evangelical Covenant Church, formerly located at the corner of Division and Rector Streets (now a private home) is now located at 1025 Main Street and is known as Christ Church. The Westminster Unitarian Church purchased in 1958 Dr. Thomas Spencer's house on Kenyon Avenue.

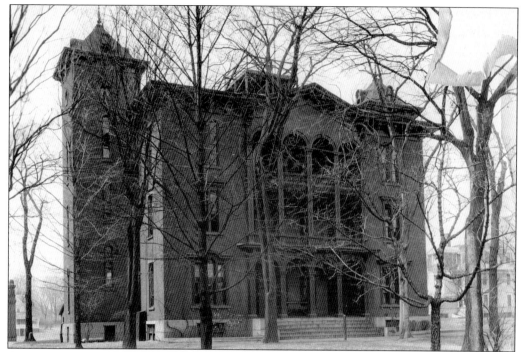

ADMINISTRATION BUILDING, PEIRCE STREET, 1858–1943. Constructed of red brick, it was three stories with two towers to house classrooms. On the top floor was an elegant chapel with a large pipe organ. The second floor held classrooms, while the first floor contained offices, a library, a museum, and more classrooms. A large cheery dining room was in the basement with a kitchen in the rear. Many stirring scenes occurred, and many a notable person passed through the doors of this venerable old private high school—Nelson Wilmarth Aldrich, Frederick Herreshoff, William Dorrance, Francis C. Lippitt. In 1943, the town bought it, and for 16 years, it served as the public high school. In 1959, it was razed. (East Greenwich Academy photograph.)

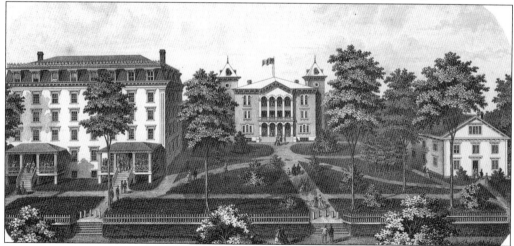

THE EAST GREENWICH ACADEMY. This was the educational and cultural center of East Greenwich for 141 years. This panoramic print, from around 1884, depicts the Boarding Hall erected in 1846, the second administration building dedicated in 1858, and Winsor Hall. (East Greenwich Academy illustration)

ORIGINAL BOARDING HALL. Located on Peirce Street, this imposing building was erected in 1846 to be the principal boarding place for students and faculty. The north half housed the gentlemen, and the south, the ladies. By 1860, enrollment had almost doubled, so in 1868, the dormitory was enlarged from three to five stories, surmounted by a French roof. A first in New England, students also had electric lights in their rooms. On August 11, 1896, a fire destroyed the entire building. Noted as one of the most beautiful and perfect examples of architecture in New England, it was not replaced until 1905 when Eastman Memorial Hall was dedicated as the girls' dormitory. (East Greenwich Academy photograph.)

SOUTH COTTAGE. This spacious house at 137 Peirce Street was rented for a ladies' dormitory by the academy after the fire of the Boarding Hall in 1896. Built in 1780, this old historic place bears a plaque identifying it as the Hawkins House. However, it could have been known by many other famous names—Wickes, Greene, Comstock, Cundall. Built in the early Republican/Greek Revival style, this three-story wooden building has a porch across the front and a large ell on the west. South Cottage was probably only used as a dormitory until Eastman Memorial Hall was completed in 1905. (East Greenwich Academy photograph.)

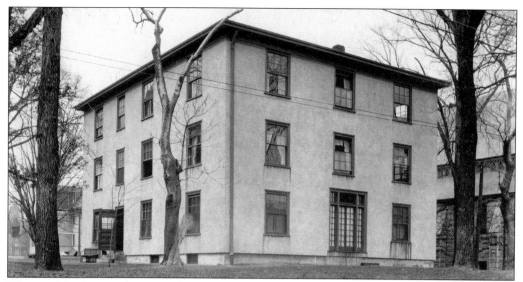

WINSOR HOUSE. At the time of its purchase in 1856 by the Methodist Episcopal Church, the Winsor house was the private residence of Joseph Winsor, an attorney-at-law, who had resided there for less than 10 years when he died in December 1853. It was a two-story wooden building with a peaked roof, a northeast ell, and a gracious entrance facing Peirce Street. Sometime around 1911–1912, the Winsor was remodeled; a third floor and flat roof were added, and the entrance was moved to its south side. The Winsor house served many purposes during its 103 years: faculty housing, girls' dormitory, music school, and boys' dormitory. The town used it from 1942 to 1959 as housing for teachers. In 1959, the town sold it to St. Luke's Episcopal Church nearby, and in 1960, it was razed to expand their parish house. (Stevens photograph.)

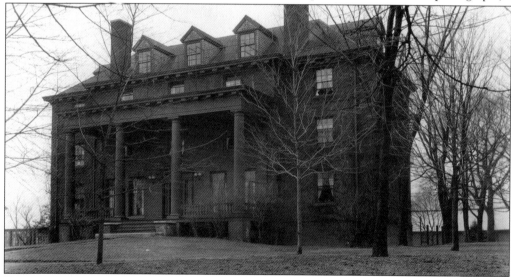

EASTMAN MEMORIAL HALL. This was the girls' dormitory and was located south of the main building on the campus of the academy on Peirce Street. Pictured here in the 1920s, the Eastman Memorial Hall replaced the original Boarding Hall that was completed in 1846, enlarged in 1868, and was destroyed by fire in 1896. In 1905, Eastman Memorial Hall was named for Prof. Joseph Eastman, faculty member from 1854 to 1881. This beautiful building was razed in the 1960s. (Stevens photograph.)

SWIFT GYMNASIUM. Erected on the southwest side of the academy grounds and dedicated in 1907, the gymnasium was a gift of Anna Swift (née Higgins) in memory of her husband Gustavus Franklin Swift, founder of Swift and Company, packers, of Chicago. Ownership passed to the town in 1943 with the rest of the academy buildings, and in 1963, it was renovated to serve as a civic center. Swift Gymnasium was considered the finest gymnasium of any preparatory school in New England, lacking nothing for the physical development of boys and girls: bowling alleys, shower baths, padded running track, basketball floor, trophy room, and locker rooms. (MacGunnigle collection.)

PROCESSIONAL. East Greenwich Academy faculty and students in cap and gown at graduation begin the most impressive ceremony of the 1940–1941 school year. (East Greenwich Academy photograph.)

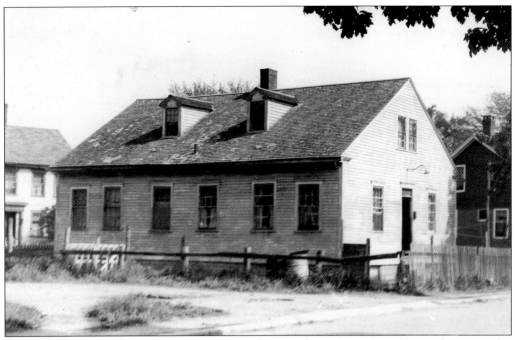

SCHOOL DISTRICT NO. 1 SCHOOL. This school was built in the early 1800s on the triangular plot between Duke and Exchange Streets. It was also used for a Baptist meetinghouse. In October 1916, the old school was destroyed by fire. A private home occupies the spot now.

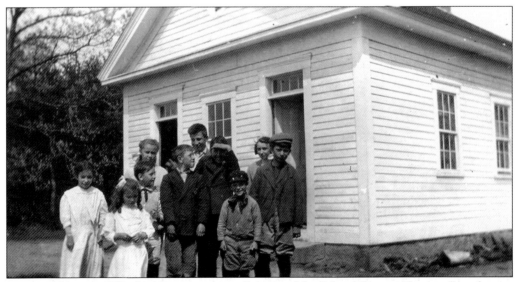

TIBBITTS SCHOOL. This building was originally erected for School District No. 4 in Frenchtown in the early 1800s. Another school was built in 1926, consolidating the four schools in that vicinity. In July 1929, the Tibbitts School was put up for public auction, and Walter Card bought it for $250.

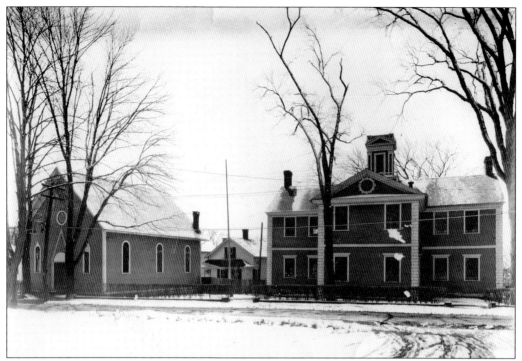

SPRING STREET SCHOOL. In 1853, the town purchased the old Kent Academy, built in 1802, and moved it to Spring Street. It served as an elementary school until 1927. For awhile, the historical society rented it as a museum for $1 a year. In 1953, it was sold for $1,000. The building has since been torn down. On the left is the Swedish Chapel (1874–1894). It was purchased in 1915 to serve the overflow from the elementary school until 1928 when the James H. Eldredge School was opened. It was auctioned off in 1929 for $400 to Philip Delin, who purchased it for the Boy Scouts. (Stevens photograph.)

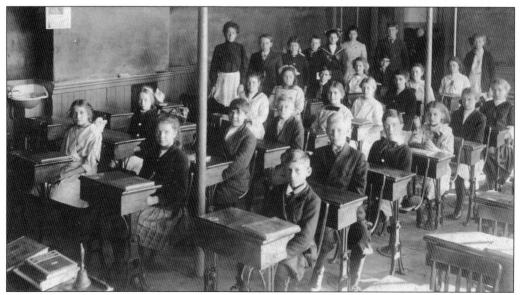

THE CLASS OF 1915. The Spring Street School class poses with its teacher E. Alice Tefft.

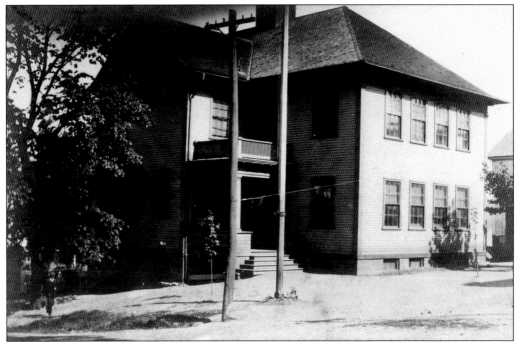

THE MARLBOROUGH STREET SCHOOL. Located at the corner of Queen and Marlborough Streets, this school was dedicated in 1898. Sold to the East Greenwich Dairy Company in the 1930s, the Marlborough Street School became the Community Foods Market until the early 1980s. This building now houses condominiums. The image is dated June 1908.

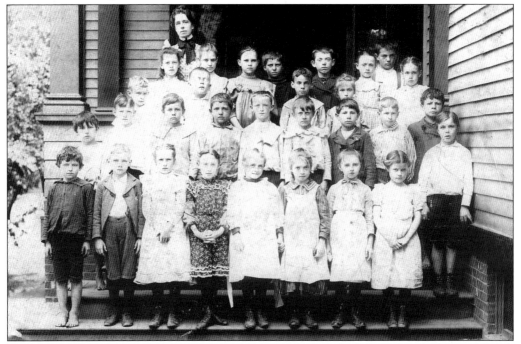

SMILE AND SAY CHEESE! Here it is class picture time at the Marlborough Street School. (Ellis collection.)

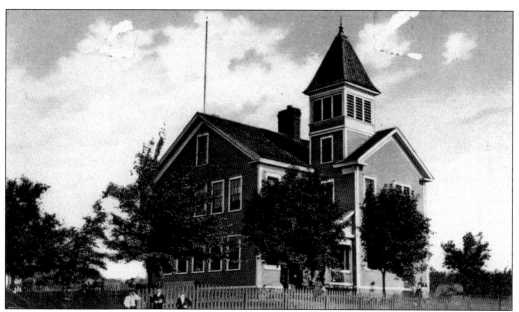

THE EAST GREENWICH GRAMMAR SCHOOL. In July 1877, land was purchased at the corner of First Avenue and Cliff Street, and in October, the first floor was dedicated—complete with desks, wardrobes, outbuildings, and fencing. In 1885, the second story was completed, making it a four-room schoolhouse. In July 1929, it was auctioned off with the understanding that the building had to be moved from the lot within 30 days. It is believed the building was dismantled and the material used elsewhere.

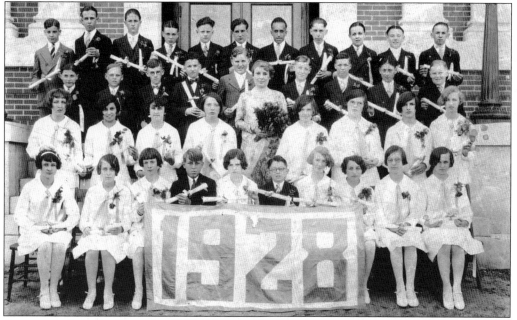

GRAMMAR SCHOOL CLASS OF 1928. This was the last class to graduate from the old Grammar School. Graduation exercises were held at the newly completed James H. Eldredge School on the other side of the field. Members of this class held regular reunions for over 75 years—thought to be the only grammar school class to do so in Rhode Island. The teacher is Florence Adams.

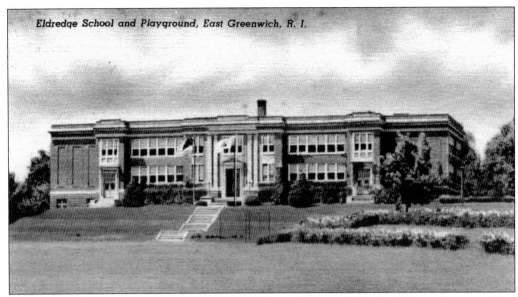

JAMES H. ELDREDGE ELEMENTARY SCHOOL, FIRST AVENUE. Finished for students arriving for fall 1929 classes, the school was named to honor local physician, civic leader, and 40-year school committee member Dr. James H. Eldredge. The school, erected on a former town dump, took considerable foundation work, performed by Secondo Cevoli and crew. The building has not sunk. The general contractor for construction was Charles T. Algren. The grounds were beautifully terraced, and a large ball field in front drew students to school early to allow a game or two of soccer before the bell.

THE ELDREDGE MEMORIAL FOUNTAIN. This fountain originally stood on the sidewalk in front of the Kent County Court House. It was moved to the site of the old Grammar School on First Avenue after the school building was razed and the new James H. Eldredge School was opened.

A LITTLE DAB HERE AND THERE. Plasterers put the finishing touches on walls and ceilings at the Eldredge school prior to its opening in 1928. This larger school building consolidated the smaller elementary and grammar schools in town. It is a fine building and is still in use today. (Gunderson photograph.)

A LIFELONG COMMITMENT. Herbert "Hub" Wilson sands the hardwood floors in one of the classrooms at Eldredge School in preparation for opening classes. Wilson continued as the school's custodian, taking care of the school for the rest of his days. He was up at dawn to get the boilers fired up for heat and more than likely was hanging around to shut down in the evening after Bertha Carr's dance recitals and other functions were over. (Gunderson photograph.)

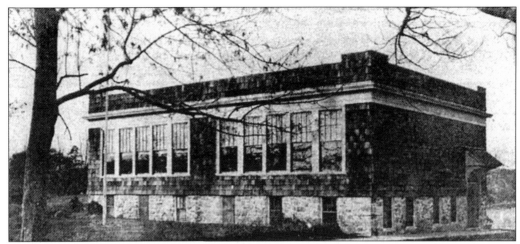

FRENCHTOWN ELEMENTARY SCHOOL. Built in 1926 to consolidate the four districts in that vicinity, Frenchtown Elementary School is located on the north side of Frenchtown Road west of Route 2. Grades 1–3 were in one room thought of as the "little room" and grades 4–6 in the "big room." The school had girls' and boys' separate entrance doors with a rather large hallway between the stairs leading from each entrance. The girls and boys each had a large basement room in which to play in stormy weather. Located here were two stall pull chain overhead flush toilets. (Fry-Bailey collection.)

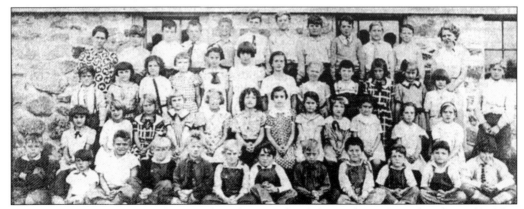

THE OLD FRENCHTOWN SCHOOL. This photograph of the students from the class of 1935 is one of several old photographs on display at the Frenchtown Annex on Frenchtown Road. The Frenchtown Annex, formerly the elementary school, is now the home of the town's recreation department. (Fry-Bailey collection.)

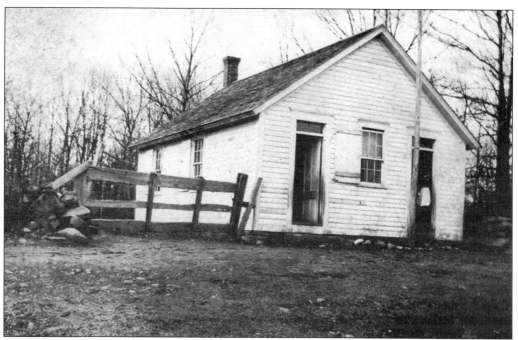

SHIPPEETOWN SCHOOLHOUSE. The one-room Shippeetown schoolhouse on Shippeetown Road was erected in the early 1800s for School District No. 3. The school burned down in 1916. (Fry-Bailey collection.)

SMILE PRETTY! Students of Shippeetown School pose in 1913 with their teacher Mary Briggs (third row, middle). (Fry-Bailey collection.)

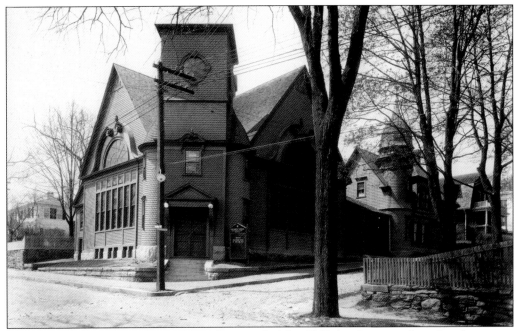

THE FIRST BAPTIST CHURCH, PEIRCE STREET. In May 1883, land was purchased at the corner of Peirce and Montrose Streets for a new church. The building was erected in three stages but used for services before completion. The first service was held in the chapel on January 10, 1886. (Stevens photograph.)

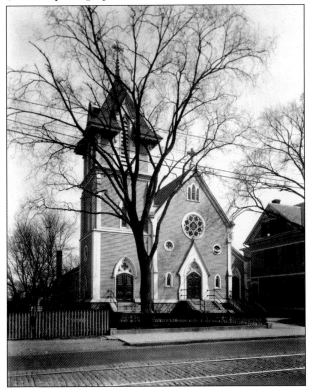

OUR LADY OF MERCY ROMAN CATHOLIC CHURCH. This complex was formerly at 500 Main Street. Martha McPartland wrote in her *The History of East Greenwich* that the church traces its beginning to the Irish immigration of 1840–1850. The present Our Lady of Mercy Church was built in the 1960s. After the new church was finished, the older church, parsonage, and carriage house on Main Street were razed. (Stevens photograph.)

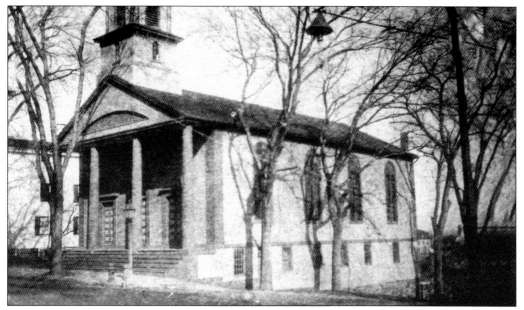

UNITED METHODIST CHURCH, MAIN STREET. The Methodist Society was organized by seven women in 1791. In 1833, its first building was erected at the corner of Main and Queen Streets. An historic Rhode Island event took place here in 1842. The Constitution Convention was held in the church, presided over by ex-governor James Fenner. A state constitution was drawn up to be submitted to the people of Rhode Island. The constitution was adopted, ending charter government, which had been in place for over 150 years. A bronze memorial tablet commemorates the event.

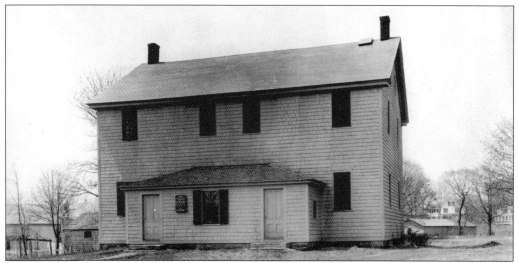

FRIENDS MEETING HOUSE (QUAKERS). In 1700, Friends from East Greenwich, Warwick, and Wickford began to raise funds to build a meetinghouse. The first meetinghouse was built on the land of John Spencer on Cedar Avenue near Payne's Pond. In 1804, they erected a new meetinghouse on Peirce Street, next to the newly (1802) established Kent Academy. It was a two-story wooden building, with the upper floor used for children's gatherings and social activities. The Quaker Meeting House on Peirce Street was razed in 1946. At this site there is a small cemetery with a state historical marker. (Stevens photograph.)

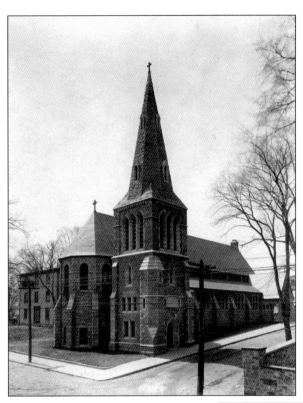

ST. LUKE'S EPISCOPAL CHURCH, PEIRCE STREET. This church, an impressive building of Coventry granite, was erected in 1875, taking one year to build and at a cost of around $32,000. It would be another 46 years before the spire and chimes were installed in 1923, a gift of Adeline Goodwin in memory of her husband, Rev. Daniel Goodwin, rector 1879–1893, who had died the year before. In 1961, the church purchased some adjoining land at the site of the former East Greenwich Academy (1802–1942) from the town and added a new parish hall and Sunday school wing.

SIX PRINCIPLE BAPTIST CHURCH. In 1726, Clement Weaver petitioned the town council for a lot upon which to build a Six Principle Baptist Church. The petitioners were granted Lot No. 54 at the east end of Division Street, running through to Wine Street. The area is still called Meeting House Hill although the church was destroyed in the gale of 1815. The present Six Principle Baptist Church in East Greenwich is the Frenchtown Baptist Church, organized 1848. Destined to be razed in 1972 for a new larger church, the Baptist meetinghouse was saved by Robert and Nancy Merriam, who had it moved to their New England Museum of Wireless and Steam Inc. property on Frenchtown Road.

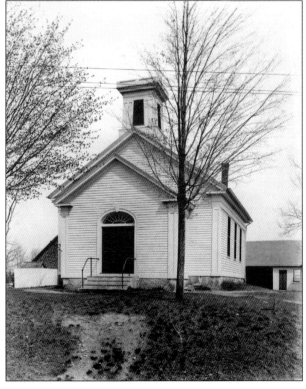

EVANGELICAL COVENANT CHURCH, DIVISION STREET. Until 1894, the Swedish people of East Greenwich worshipped in the little church on Spring Street. When some of the members joined the Augustine Synod, others separated from the group and founded the Evangelical Mission Church. They met in houses and other Protestant churches until 1895 when the Evangelical Covenant Church was erected on the corner of Division and Rector Streets. There were 22 charter members. The church was a member of the Eastern Missionary Association and the Evangelical Covenant of America. It closed because of so few remaining members and is now a private home. (Stevens photograph.)

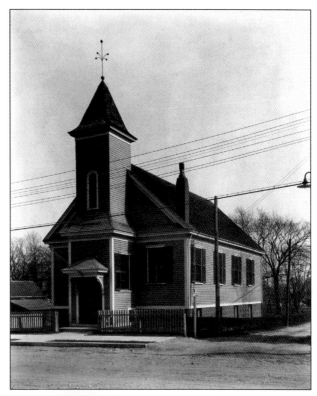

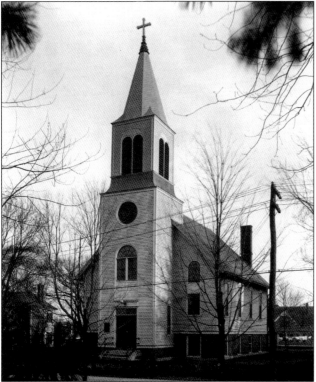

FIRST EVANGELICAL LUTHERAN CHURCH, DIVISION STREET. In 1874, forty-one persons of Swedish extraction met to form a church. The first edifice on Spring Street was built by William R. Kenyon, a local carpenter, but the entire interior was finished by the parishioners. The church was dedicated on December 11, 1874, and stands today as the Boy Scout Hall. In 1904, they bought land on the corner of Division and Brayton Streets and erected the present church. Henry E. Turner said in his "Reminiscences of East Greenwich" that all services were conducted in Swedish. For some years, English and Swedish were used alternately, but in 1943, Swedish services were dropped. (Stevens photograph.)

JEMIMA MEETING HOUSE. Jemima Wilkinson was "the first native born American woman to found a religious society," wrote Herbert A. Wisbey Jr., author of *Pioneer Prophetress*. She was born in Cumberland on November 29, 1752, the daughter of a Quaker family. An avid reader, she could quote the Bible at length. At age 24 she fell ill, was unconscious many hours, and nearly died. She maintained that a call to preach came to her while she was "dead." She called herself "the Publick Universal Friend," held meetings in private homes and public places, and was disowned by the Quakers. In 1778, she went to South Kingstown and made numerous converts, including Judge William Potter, who added a wing on his house for her to hold meetings. A meetinghouse was built for her by followers in East Greenwich on the east side of South County Trail, next to the Lewis Farm. (*East Greenwich, R. I., 300 Years, the Tercentenary Book, 1677–1977.*)

MARLBOROUGH STREET CHAPEL. In 1872, William Northup Sherman, editor of the *Rhode Island Pendulum*, built the chapel at the corner of Long and Marlborough Streets. It seated 300 people, had a pipe and reed organ, and boasted the finest toned bell in town. His purpose in building and supporting this church was because "many persons in this village are unable to purchase a pew or hire a seat in any of the churches here, but at the Friend's Meeting House or at the Marlborough Street Chapel they can worship whenever they choose, free of charge." William and Mary Sherman had previously invited African American children into their home on Peirce Street to teach them to read and introduce them to the Bible. The building, for a time, was the home of the American Legion Post No. 15, and it stands today as a private home. (Clarke photograph.)

Seven
EARLY MILLS AND INDUSTRY

As with every important and historic town in America, there is an ebb and flow of prosperity. So too, East Greenwich passed through a thriving mill era. Near the corner of Post Road and Cedar Avenue once stood a landmark known familiarly as "the Bleachery." This mill closed down about 1960, having stood there for 120 years. It was demolished a few years later.

Its beginning was in 1840 as the Green Dale Bleachery, a steam-powered textile finishing plant. Over the years, it changed countless ownerships, several name changes, and survived two fires. It employed generations of local residents, many of them skilled immigrants. In the early years, it was a print works, printing mouslin de laine, the first such in the country. This rich and beautiful dress fabric sold in Boston, New York, and other cities with a French label. Many women thought they were buying imported material. Town residents still recall the 120-foot tower and the mill whistle that could be heard all over town every day.

In 1812–1814, the first cotton mill was built by Dr. Elder Thomas Tillinghast, an educated man who served as pastor of Seminary Six Principle Baptist Church and as a medical doctor, having studied with Dr. Peter Turner of Peirce Street. Its proper name was Mount Hope Manufactory, but commonly, it was called the Tillinghast Factory.

Powered by waterwheel, it was located along the headwaters of the Hunts River. The original building was four stories high, with the first two stories of fieldstone. Power was furnished for 57 years by a wooden overshot waterwheel measuring 28 feet in diameter, 5 feet across the floats, and reached three floors. In 1871, the wheel was replaced by an iron wheel and, later, by a brass turbine.

The cotton yarn spun in the factory was woven into cloth on hand looms by the womenfolk of Frenchtown. Printed cloth was made until 1870. Later carpet warps and twine were made by Benjamin Moone, the factory being then known as Moone's Mill. Operations ceased in the early 1900s. In 1912, Thomas Barker bought the mill and sold its contents. In the early 1970s, the Town of East Greenwich acquired the property. It is now known as Frenchtown Park.

The park's entrance is on Frenchtown Road west of Route 2 near the old wooden Frenchtown School, which still stands. A slate marker tells the story of this factory and community—an outstanding example of this part of East Greenwich history. The wooden superstructures have been removed, but the stone piers that once supported the flume and the stone foundations of the wheelhouse and mill houses can still be seen in the park.

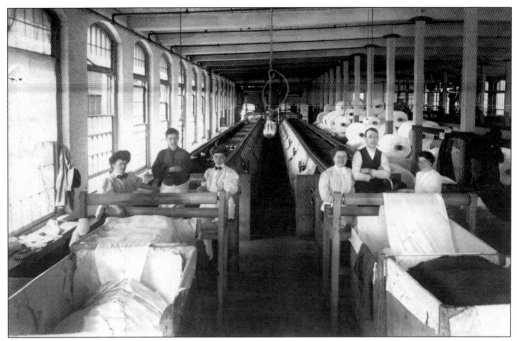

INSIDE THE BLEACHERY PROCESSING AREA. Almost every family in town had someone working at the Bleachery at one time.

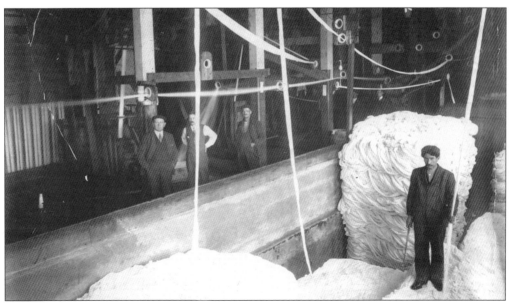

It is hard to believe that there is scarcely a trace of the Bleachery's massive complex today. At one time, there were at least 14 large buildings, landscaped grounds, gatehouses, and siding tracks that led to the nearby railroad lines.

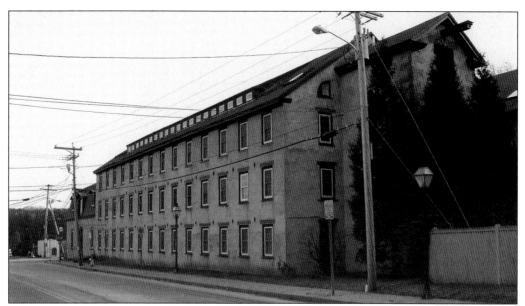

SHORE MILL, KING AND WATER STREETS. The condominiums at Historic Shore Mill at Greenwich Cove since 1990 are housed in buildings that date back to the early 1840s. An earlier stone mill was destroyed by fire in 1839. The 1842 mill was a four-story stone building with heavy timber and post framing in the Greek Revival style. A mansard addition was erected in 1859. From 1842 to 1983, a number of industries employed many local people. The Bay Mill, Elizabeth Mill No. 2, and Shore Mill manufactured cotton cloth; Hill and LaCross produced elastic; Bostitch occupied the space for about seven years; and Reukert Manufacturing made plush jewelry cases, displays, and tool and instrument cases. (Clarke photograph.)

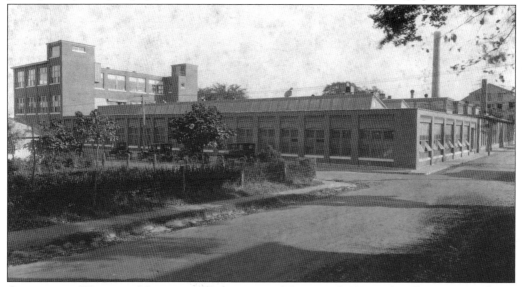

GREENWICH WORSTED MILL, 1918. Sole owner of Greenwich Worsted Mill was Granville A. Beals, who came to East Greenwich from New York. Greenwich Worsted was a very superior worsted cloth for men's suiting, a well-known product throughout the country. The mill complex was sold in 1945 to Verney Corporation. It still stands at the corner of Duane and Ladd Streets and is home to several small businesses. (Stevens photograph.)

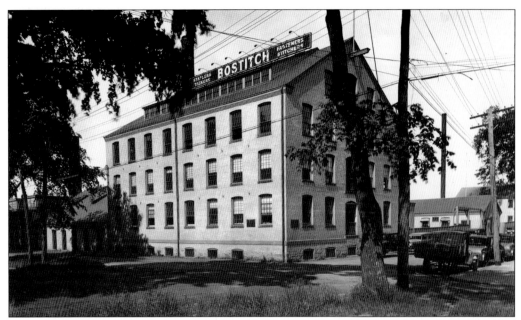

BOSTITCH INC. In 1896, Thomas A. Briggs of Arlington, Massachusetts, invented a new kind of wire stapling machine, which he called the Boston Wire Stitcher. He moved here in 1904 with eight employees, destined to become the town's largest manufacturer, Bostitch. The company occupied this very large manufacturing complex at Division and Duke Streets from 1904 to 1946. After a decade out of town, Bostitch returned, opening its new plant on 84 acres on South County Trail in 1957. (Stevens photograph.)

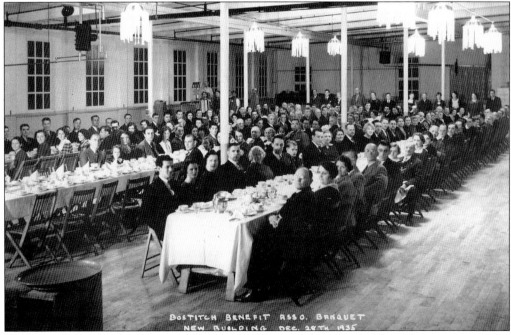

BOSTITCH BENEFIT ASSOCIATION BANQUET. This is a function held on the occasion of the opening of a new building at the Division Street plant, on December 28, 1935.

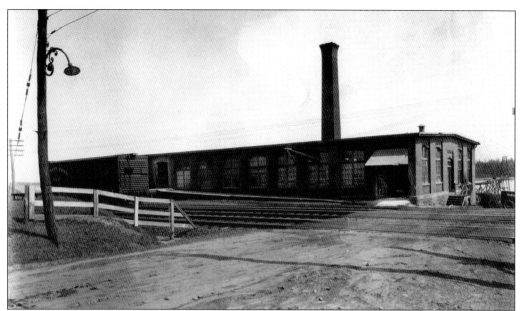

FARRINGTON MILL AT FERRICUP DOCK SINCE 1905. Located at the foot of Division Street, the 10,000-square-foot building was the third mill built by William Unsworth Farrington. Its principal product was dextrin, used extensively in calico printing, and adhesive gums. Farrington was skilled in the business of finishing cotton fabrics. The previous building owner was Ferry Cup Metal Corporation. The building is currently occupied by a sail loft. (Stevens photograph.)

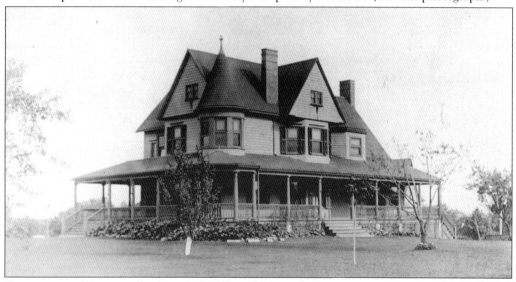

CEDARCREST. This was the home of William Unsworth Farrington, mill owner, built in 1893 just south of East Greenwich on Post Road. Born in Harwich, England, in 1852, Farrington came to America around 1877. He worked at mills in Providence and moved to East Greenwich in 1885 as manager of Bolton Manufacturing Company, later known as the Greenwich Bleachery. Farrington died in 1906. Laura Farrington, William's wife, continued to live at Cedarcrest until 1919. After that, the property was used as a restaurant, a men's gambling establishment, and in May 1937, it became the Greenwich Club. In 1963, a pool was installed, and it is now a family swim and social club.

J. O'BRIEN BLACKSMITH SHOP. This image, taken June 1908, shows the J. O'Brien Blacksmith Shop, one of several blacksmiths in East Greenwich at the time. It is on London Street, looking east from the tracks. Several old pictures of East Greenwich show buildings pasted with circus posters, which never seem to have been removed but pasted over and over each other.

ASA ARNOLD MACHINE SHOP, BUILT AROUND 1775. This structure no longer stands at the southeast corner of Division and Marlborough Streets. At the height of textile manufacturing during America's Industrial Revolution, Arnold, a local millwright, invented and patented the Double Speeder. This was a device that increased the amount of thread that could be prepared at one time. Sadly, he lost the title when one manufacturer simply stole the design. His son Benjamin later used the shop for making machinery he invented for the knitting of seines and fishnets. After Benjamin's death, the structure was adapted to other uses such as, pictured above, the William Barry Plumbing Company.

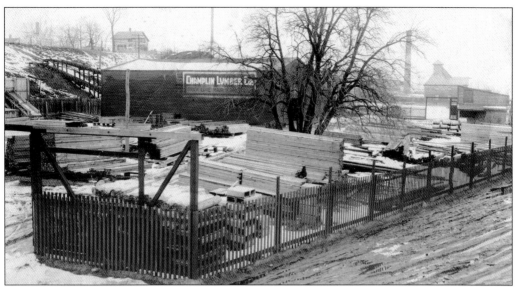

R. H. Champlin Lumber and Coal Yard, Water Street. Just below the Arch Railroad Bridge was a roadway that turned north. At the northeast corner of this turn stood Robert Champlin's house, which was later moved to Duane Street. Champlin had a lumberyard that did not survive the hurricane of 1954. He kept a planing mill nearby, which was still operating in 1960. The most recent transaction of land and buildings from Champlin to the East Greenwich Yacht Club at King, Division, and Water Streets occurred in October 1983. The Champlin family in the area dates back to 1819. (Earnshaw photograph.)

All Aboard! This is one of two taxi wagons operated by Henry Weeden from 1900 to 1920. Six horses were needed to draw a wagon. The stable to house the horses was at King and Duke Streets. The wagons took groups on outings and clambakes. The driver also met the electric trolley cars and carried families out to the Crawford Allen Children's Hospital on North Quidnessett Road. That place is now known as the Scalabrini Villa, a nursing home.

A Mill on Main Street. A business identified with the industrial life of Kent County since 1894 was the Providence Drysalters, which bought the Union Mill, a brick factory built in 1836 at 459 Main Street, to manufacture paper coating materials for lithograph, book paper, and textile chemicals. One leading product was Satin White. The company was the first in America to produce Satin White in large enough quantities so that it was affordable for general use. In 1927, the Providence Drysalters was producing over 400 carloads. In 1939, Hercules Powder, a division of E. I. du Pont, purchased the mill and operated it until 1946. During World War II, the mill produced the color used in dyeing army uniforms.

Dusty Business. Drysalters in the early 1930s take a break for a photograph.

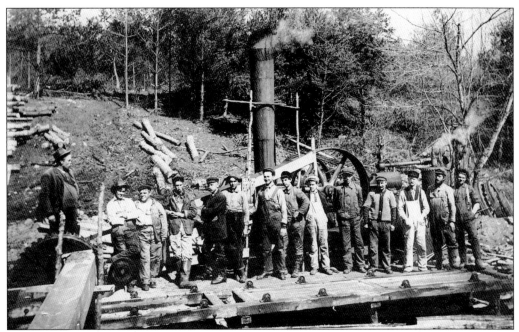

SAWING WOOD. Workers pose at a steam-driven portable sawmill in the Carr's Pond area for this c. 1913 picture. Timber was sold to joiners for constructing desks, chests, bedsteads, and so on. Lumber for houses was cut and sawed as planks at up-and-down sawmills in the countryside until the early 20th century. Shanties were erected to house the men. On weekends, they went home. The great heaps of sawdust left behind were sold to stable owners and farmers.

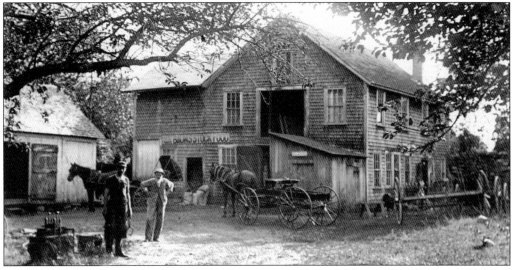

WILLIAM N. ALLEN'S GRISTMILL AND BLACKSMITH SHOP. About 1870, William N. Allen (1835–1918) operated a gristmill/grain store and associated blacksmith/carriage repair shop here. This was located on Frenchtown Brook, at the corner of Davisville and Ayrault Roads. Gristmills were located on streams of water used to turn the wheels of the machinery. Families brought their corn to the gristmill to be ground into cornmeal. White-capped corn was ground for johnnycake meal. In 1969, the buildings, having been vacant and vandalized for some time, were severely damaged by fire and were razed later for construction of Route 4.

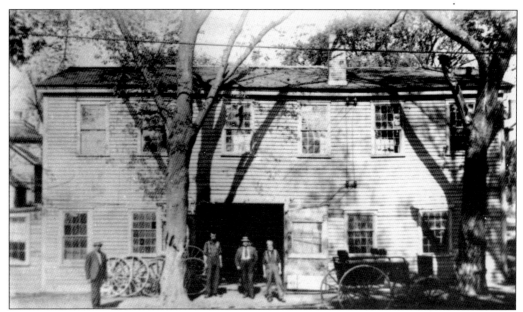

BLACKSMITH SHOP, 333 MAIN STREET, AROUND 1800–1900S. The original owner was David Potter (1820–1894), and later it was owned by Clark B. Wells (1863–1969). Between 1795 and 1835, there were nine blacksmiths on record in and around East Greenwich. As long as horses and oxen remained on the farms, the smithy was in demand. Pete McKone's blacksmith shop on Main Street south of Peirce Street, center in the picture below, was one of the last. In later years, when farm horses no longer traveled on the roads, McKone often visited the farms to trim the horses' hooves. South of McKone's Blacksmith Shop was Arnold's Stable. Later on, this building housed the town's school buses run by Pete McKone's nephews Francis and Ken Convery. Arnold's Garage also housed a fleet of cabs and Kohl Motors, a Chevrolet dealership.

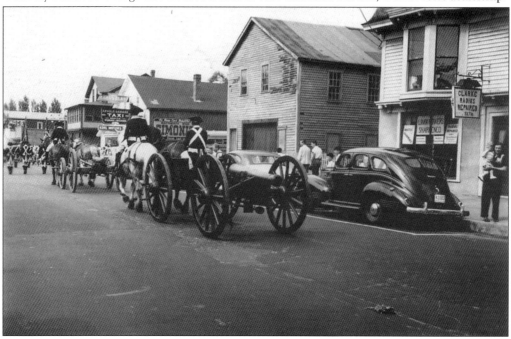

Eight
TOWN FUNCTIONS, PAST AND PRESENT

The Town of East Greenwich was incorporated October 31, 1677, and empowered to meet on the next second Wednesday to constitute a town meeting.

At the first town meeting, the following were to be elected: a town moderator, town clerk and such constables as needed. They would also choose two persons as deputies to the General Assembly and two persons on the grand jury.

John Spencer, an original grantee, was the first town clerk, serving from 1677 to his death in 1684. That year, John Heath became town clerk and served until 1712, a total of 28 years. His writing is well preserved and quite legible.

On June 1678, the name of the town was changed to Dedford but reverted to the original name in 1689.

In 1740, the township was divided into towns of East and West Greenwich. In 1750, Kent County was set off from the county of Providence, including East Greenwich, West Greenwich, Warwick, and Coventry, and East Greenwich was selected as the county seat. Here was furnished a lot on which a courthouse and jail were erected.

In 1708, the population was 240, then 1,664 in 1776, 4,000 in 1876, and currently it is 12,948 (2000 Census). Early town meetings were held in homes or taverns.

In 1972, voters of East Greenwich adopted a council-manager form of government. The town manager is selected by the town council, a five-member legislative body. There are seven members on the School Committee, and a town moderator presides over the financial town meeting. Most of the town offices are located in the historic Kent County Court House on Main Street.

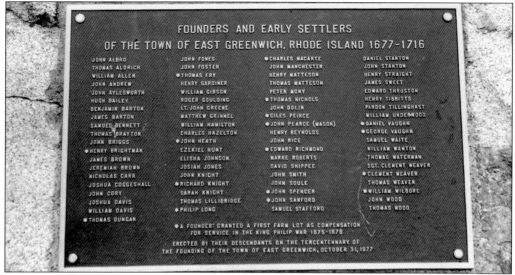

EARLY SETTLERS MEMORIAL. Founders Rock commemorates the 48 men who were awarded 5,000 acres of land in East Greenwich by King Charles II of England in recognition of their services during the King Philip War. The memorial rests in front of the Old Kent County Jail of 1795 at 110 King Street, headquarters of the East Greenwich Historic Preservation Society. The boulder came from the Fry farm, home of Marion L. Fry (1912–1995), which her family had owned since the town's founding.

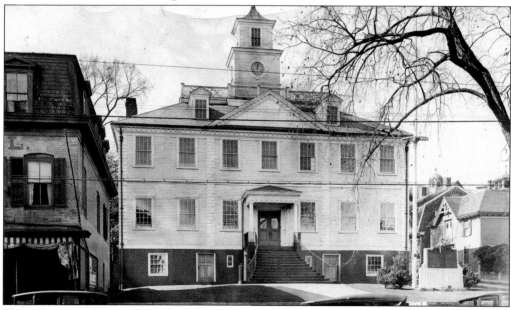

KENT COUNTY COURT HOUSE, MAIN STREET. In 1750, when East Greenwich was designated as the county seat for Kent County, a small courthouse was erected on this lot donated by John Peirce, town clerk. In 1803, the Rhode Island Assembly voted to build a new, larger courthouse on the same lot. This Federal-style building was completed in 1806 and remains one of the few surviving buildings of its size in the state. A dignified and proud landmark, it has been the seat of political, social, and economic activities for close to 200 years. After a time of disrepair, the town restored and rededicated it on May 4, 1996, as the East Greenwich Town Hall.

WOODEN FIGURES. According to Henry E. Turner in his "Reminiscences of East Greenwich" of April 11, 1892, in his childhood and early youth, the jail on King Street had "two specimens of scripture on its exterior front. These figures were images of wood, one supposed to represent a murderer, the other a robber. Both were ornamented with iron wristlets, and fetters, and chains, and were painted, the one black, the other white, and the jail itself was always painted yellow, so that the characteristic statuary, being placed in each side over the front entrance, stood out in hold relief as guardian angels of this harbor of refuge."

THE FIRST KENT COUNTY JAIL, 1780–1796. The first Kent County Jail stood at the southwest corner of Marlborough and Queen Streets for close to 200 years. The jail was constructed of solid oak four inches thick and fastened to the timbers with large wrought iron handmade spikes. Records tell of cells in the basement. In 1796, it became a private home when the second Kent County Jail opened at 110 King Street. Around 1905, it became a two-family home. In the mid-1970s, it was extensively damaged by fire and was razed. Today a contemporary dwelling stands at this corner.

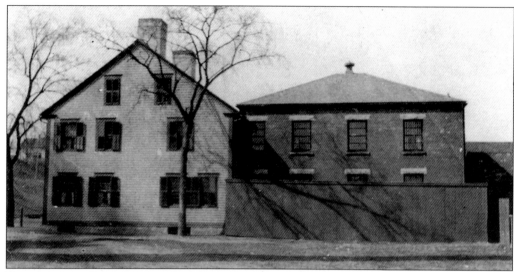

THE SECOND KENT COUNTY JAIL, 1795–1957. Saved from being razed after the state no longer needed it, the jail, since 1969, has been the headquarters of the East Greenwich Historic Preservation Society. The society, and authors of this volume, have accumulated many interesting and intimate details of this very old structure, both the jail keeper's home, which faces King Street, and the jailhouse, which is attached to the back of the jailer's house.

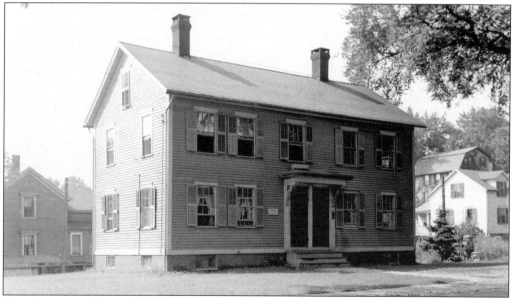

OLD CUSTOMS HOUSE, BUILT AROUND 1790. Located at 33–35 Division Street, this house apparently was originally built on the waterfront, probably at the foot of Division Street. The lot on the corner of Division and Duke Streets, where the house now stands, was empty according to early maps, but an 1879 map has a building on this corner. An item in the *Rhode Island Pendulum* dated August 19, 1887, mentions an incident "on the old Custom House Wharf," which indicates the Custom House was no longer there. Consequently, the move would have been after 1879 and before 1887. Capt. Thomas Arnold (1740–1821), was appointed the first surveyor of the Port of East Greenwich by George Washington. The building is Federal style with Victorian remodeling. (Stevens photograph.)

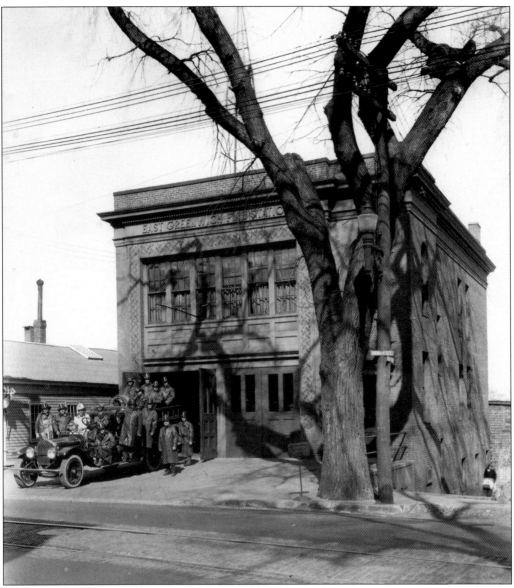

VOLUNTEER FIRE STATION, MAIN STREET. East Greenwich seems to have always had a very active volunteer fire department. From the early days of bucket brigades, local citizens would drop what they were doing and respond in force to the call of the fire bell. Until recently, the station had a loud horn that would sound, blasting out a code that volunteer firemen could decipher, learning the location of the fire and where to go if they could not make it to the trucks. Merchants along Main Street understood that most of their workers would head out to the fire, leaving them to wait on customers and take care of business. The volunteer spirit was always high, and they never failed to turn out a smart complement for a parade. Fire trucks, sometimes 50 years old, were kept in peak condition, polished and mechanically ready to go. Competition with other departments took place at summer musters all over New England, and using their old hand tub, the *Volunteer*, more often than not they would win. Today the volunteers, replaced by a paid fire staff, have retired to a social club at the Firemen's Hall on Queen Street, where they also maintain a museum of antique fire trucks and assorted memorabilia. (Stevens photograph.)

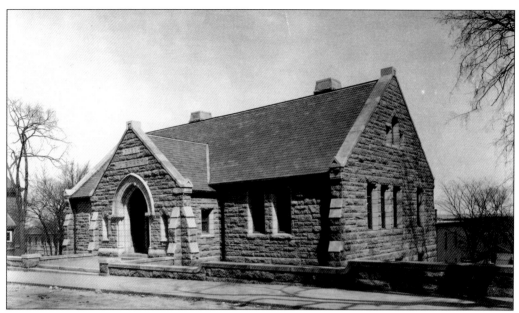

EAST GREENWICH FREE LIBRARY, PEIRCE STREET. This handsome structure made of Coventry granite was dedicated June 29, 1915. Bounded between Armory and Church Streets, this lot and building was donated to the town by Daniel Albert Peirce, a trustee and treasurer of the East Greenwich Free Library Association. The library was constructed without regard to cost and is really a memorial to the Peirce's adored daughter, Adeline Vaughn Peirce, who died as a young child. A large addition has recently been added to the original building. Below is an interior view. (Above, Stevens photograph; below, Earnshaw photograph.)

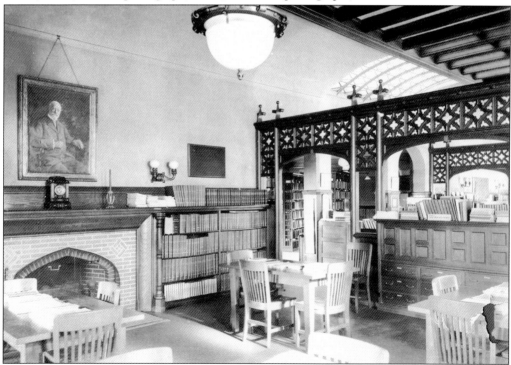

Nine

PEOPLE

It took a wide assortment of people to create East Greenwich, to steer it through its times of trial, and to ease its growing pain. With a healthy workforce of locals and recent immigrants, all eager to realize the American Dream, East Greenwich drew the creative inventors, the businessmen, and the visionaries who built the mills and factories. The East Greenwich Academy brought the bright and the gifted. The fishermen and farmers brought the food. Life was good in East Greenwich.

In this chapter are a few of the people who left a mark on the town's development. One was Thomas May, an extremely important businessman. At retirement, he invested in real estate at Mayville, a hamlet on the south end of Greenwich Cove. He built two cottages on South Main Street, known as the May villas. The *Rhode Island Pendulum*, dated August 29, 1890, noted that Thomas May had finished a 41-foot-wide bridge over the railroad at Bridge Street, at his own expense, as part of an agreement with the town. This forever lays to rest the question on everyone's mind as to why they call it Bridge Street.

Another who left a mark was Annie Josephine (Josie) Hall. Josie Hall, daughter of Albert A. and Marion Josephine Hall, was an East Greenwich girl who achieved success in the theatrical profession. The local newspaper mentioned her natural beauty, her instantaneous success, and her popularity. It also documented some of her engagements and her visits home with her family.

William N. Sherman died March 2, 1832, at the age of 73. He was founder of the *Rhode Island Pendulum*, the local newspaper, first published in June 1854. He had taken over ownership of another weekly newspaper called the *Kent County Atlas* and renamed it the *Weekly Pendulum*, choosing that name because it would be published in Wickford one week and then swing over to East Greenwich the next week, back and forth like the pendulum of a clock. He and his wife, Mary M. Sherman (née Bliss), and their daughter moved to Elm Street (now Peirce Street) to the 1854 house known as Rose Cottage. Concerned about the social conditions in town, they organized a Sabbath school, meeting in their basement to sing and learn from the Bible. In 1873, he built at his own expense the Marlboro Street Mission Chapel, open to anyone who wished to attend. Upon his retirement, the Sherman family moved to Vermont. Rose Cottage later was purchased by the East Greenwich Academy for its headmaster's residence.

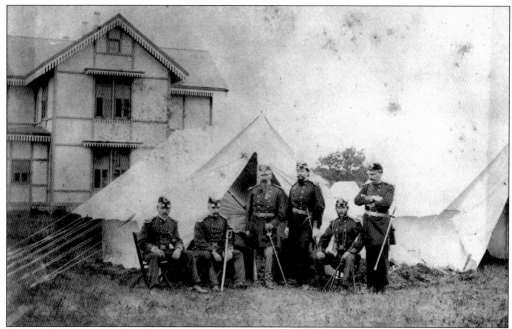

ENCAMPMENT. Seen here is Maj. Will E. Brown of the Kentish Guards and his staff at Camp Littlefield, Oakland Beach, in July 1879. From left to right are unidentified, Major Brown, Alonzo Babcock of Westerly, unidentified, Lt. John Brown of the Kentish Guards, and 1st Lt. William R. Sharpe, also of the Kentish Guards.

CLARK B. WELLS (RIGHT), 1863–1969. Son of Jabez Wells and Susan Wells (née Carpenter), Clark B. Wells was one the last old-time blacksmiths in Rhode Island. He learned the trade during the winters of his boyhood and operated his own blacksmith shop in East Greenwich. Later he went to work for the New Haven Railroad as a blacksmith. When he retired in 1936 at the age of 73, he turned to carpentry "to keep busy." He was a regular participant at square dances at the Rocky Hill Grange, even in his 80s. Pictured here, Wells talks with Dr. Benjamin Franklin Tefft. Recognized as the oldest living member of the Kentish Guards, he marched or was driven in Memorial Day parades in town until he passed away at 104. (Kentish Guards photograph.)

THOMAS MAY OF MAYVILLE. Thomas May was a successful mill man through his own industry and thrift. He was the son of Thomas May and Mary Mercer May, born in Yorkshire, England, on May 31, 1819. His father operated a power loom in a mill in Whiteash, and Thomas went to work in the weaving room there at age 7. In 1867, he moved to East Greenwich where he became foreman for Adams and Butterworth, one of the local mills occupying what was called the Bleachery. (J. R. Cole's *History of Washington and Kent Counties*.)

GEORGE BATCHELDER LANGMAID, 1848–1913. Dr. George Batchelder Langmaid was a local physician whose residence was on Main Street just south of the old town hall. A graduate of Boston University, class of 1877, he became a Mason, an Odd Fellow, surgeon of the Kentish Guards for 20 years, and also joined the East Greenwich Yacht Club when it was formed. In October 1900, his power yacht was christened the *Golden Rod* by Raymond Booth, the three-year-old son of his engineer. In 1911, at the age of 63, he married Florence Milford Briggs of Rocky Hill. He died in 1913 and is buried in East Greenwich Cemetery. (J. R. Cole's *History of Washington and Kent Counties*.)

JOSIE HALL, ACTRESS. In 1883, Josie Hall was with Rice's Theatrical Troupe for nearly a year visiting the principal cities of the west. In 1888, she had two engagements at the Providence Opera House (built in 1872) as Peach Blossom in *Under the Gaslight in June* and with the Evangeline Company in October. In 1889, Hall went to Paris and south of France. In December 1893, she was with Charles Frohman's Aristocracy Company of Philadelphia when she learned of her father's death and returned home. Also surviving at her father Albert A. Hall's death in 1893 were her sister Marion Bessie Chesebrough and her brother, Albert Holden Hall, leader of the Livingston Bank. (Conley's Portraits, Boston.)

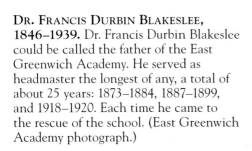

DR. FRANCIS DURBIN BLAKESLEE, 1846–1939. Dr. Francis Durbin Blakeslee could be called the father of the East Greenwich Academy. He served as headmaster the longest of any, a total of about 25 years: 1873–1884, 1887–1899, and 1918–1920. Each time he came to the rescue of the school. (East Greenwich Academy photograph.)

Prof. George Washington Greene, 1811–1883. Prof. George Washington Greene, a relative of Gen. Nathanael Greene, was a scholar, author, and diplomat. He served as U.S. consul to Italy from 1837 to 1845 and there met his famous friend Henry Wadsworth Longfellow. The Windmill Cottage was purchased for the professor in 1866 by his friend Longfellow. Later the windmill was added to the cottage to serve as a study for Professor Greene and for Longfellow himself when he often visited East Greenwich. (*East Greenwich, R. I., 300 Years, the Tercentenary Book, 1677–1977.*)

Alice C. Updike, 1804–1895. Alice C. Updike was a daughter of Daniel and Ardeliza Updike. In 1825, Daniel Updike took over Arnold's Inn on Main Street and changed the name. He had married Col. William Arnold's daughter Ardeliza. Upon Daniel Updike's death in 1842, his son Lodowick took over the Updike Hotel, assisted by his two sisters, Alice and Abby. None of the three married. Alice was 91 when she passed away in 1895. In 1896, the old inn was torn down and replaced by a new modern hostelry that still stands today. (E. R. Slater photograph.)

THE ADELPHIANS, 1899, EAST GREENWICH ACADEMY. In 1854, the Adelphians was one of three literary societies founded at the East Greenwich Academy. They held a prominent place in school life until 1918, when they were abolished. Pictured from left to right are (first row) W. N. Collins, H. F. Powers, and Arthur Cady; (second row) Fred Phillips, J. W. S. Lillibridge, T. F. Reneau, and H. V. Bingham; (third row) C. Atwater, J. Waldo Carpenter, C. M. Wilson, W. F. Reynolds, and C. L. Swift. (Lillibridge collection.)

THE EXECUTIVE COMMITTEE. These are events planners for the 250th Anniversary Celebration of the Founding of East Greenwich, September 4–8, 1927. Seen here from left to right are (first row) Howard V. Allen and chairman Herman N. Silverman; (second row) Dr. Fenwick G. Taggart, A. Studley Hart, and J. William Corr. (Stevens photograph, Silverman collection.)

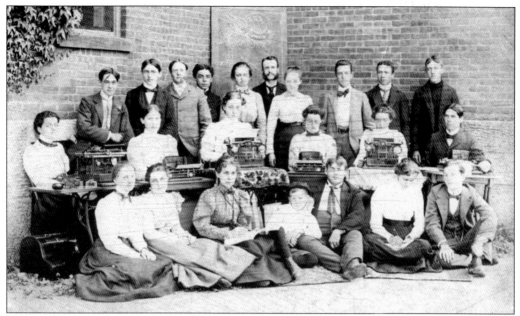

EAST GREENWICH ACADEMY COMMERCIAL CLASS OF 1890. The private school offered individual teaching in "bookkeeping, business penmanship, business arithmetic, spelling, correspondence, commercial law, invoices, stenography and type-writing." Remington Standards were used. In the 1890 class there were 15 gentlemen and five ladies; 15 students were from out of town and 5 were from East Greenwich. (East Greenwich Academy photograph.)

CONSTRUCTION COMMITTEE. Pictured are the builders for the 250th Anniversary Celebration of the Founding of East Greenwich, September 4–8, 1927. Seen here from left to right are (first row) Axel N. Shogren, chairman Charles T. Algren, and Robert P. Graham; (second row) Albert Krans and Charles Olson. (Stevens photograph, Silverman collection.)

HOUSE CALLS MADE CHEERFULLY. This is Dr. Fenwick G. "Doc" Taggart on Main Street in one of the earlier automobiles. Doc Taggart was born in 1875 in Vermont and died in East Greenwich in 1962. His wife was Edythe Miller. In 1894, Taggart began 10 years of service with the 1st Regiment of the Volunteer Infantry of the Vermont National Guard. He saw active duty as a sergeant in the Spanish-American War. He graduated from the Vermont Medical College in 1903 and came to East Greenwich by trolley in 1904 to help the local doctor deal with a flu epidemic. The local doctor died in the epidemic, and Taggart stayed on, serving the town as the village doctor for 59 years.

JASPER SPENCER, c. 1863. Jasper Spencer was born 1841 in the Brownbread House on Middle Road. In 1861, he enlisted in the 1st Rhode Island Volunteer Cavalry and served in the Civil War until its end. In 1866, Jasper married Susan Vaughn, and in 1895, after her death, he married Annie Shippee Jester, widow of Benjamin B. Jester. The Spencers lived on Marlborough Street behind the town hall.

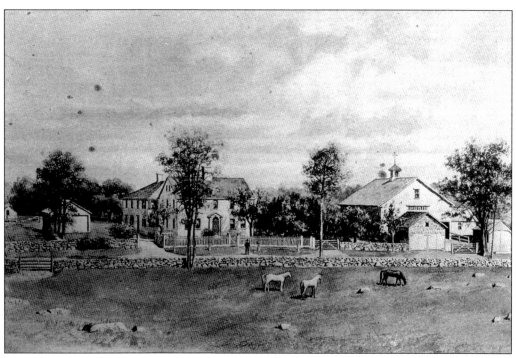

LAURISTON H. GREENE AND FARM. Lauriston H. Greene was the son of William Greene and Abigail Greene (née Reynolds). He was born in 1833 and died in 1916. Previous to adhering to the laborious pursuits of a farmer on the property he was born on, he learned the trade of a manufacturing jeweler with his brother William in Providence. He did this for 10 years, much of the time as a foremen. Upon the death of his brother George F. Greene in 1860, Lauriston returned to East Greenwich, settled on the estate, and began the life of a farmer. His sister Mary married Joseph Fry, and his sister Elizabeth married John Pitcher. (J. R. Cole's *History of Washington and Kent Counties*.)

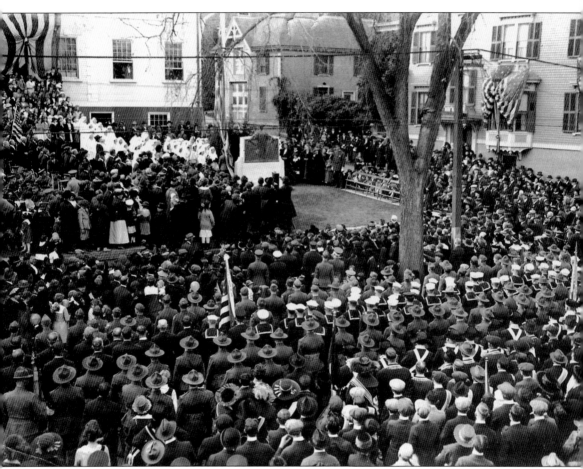

DEDICATION. The World War I monument was unveiled on October 22, 1919, on the courthouse lawn. It is of clear white granite partly surmounted by the goddess of victory, Nike, in bronze and the names of all the East Greenwich warriors inscribed on the back, both returning heroes and those who lost their lives. Of the 17 men who served in this "war to end all wars," five gave their lives. Jesse A. Whaley, who unveiled the monument, was blinded by an exploding grenade.

Ten

Fry's Hamlet

This historic district contains three adjoining farmsteads and has been an agricultural community since the 17th century. South County Trail, Route 2, runs through the district in a north-south direction and was one of the highways laid out in the division of lands in 1677. Fry's Hamlet is characterized by rolling terrain kept as pasture, cropland, woodland, and swamp divided by networks of dry-laid fieldstone walls. Fry's Brook flows through the district in its southeasterly course to Hunt's River.

For their services in the King Philip War, two residents of Newport were granted land in East Greenwich, the 17th farm allotted to pieces of property to John Spencer (died 1684) and the 18th farm to Thomas Fry (1632–1704). Thomas Fry III (1691–1782) continued to farm the homestead farm and filled a number of public offices, serving three terms as a deputy and two terms as a chief justice of inferior court of Kent County. Thomas III's son Joseph (1736–1823) inherited his father's farm, and it was he who built the present Joseph Fry house after the existing farmhouse burned in 1793. Joseph devoted his energies to farming and also held public office such as a justice of the peace after the war.

In 1798–1799, Joseph's son Thomas Fry IV (1765–1831) purchased the former Walter Spencer farm on the east side of the road and created the second phase of the farm. This farm remained in the Spencer family until after the Civil War. In the late 18th century, it had become a part of the large Ebenezer Spencer farm to the east. Ebenezer turned the smaller property over to his son Charles, who farmed here until his death in 1870. It was then sold to Javis Himes in 1876 and to Stukeley Brown in 1879.

In 1890, William D. Bailey purchased the farm for his homestead. This Bailey was related to the Spencers through his mother, and his sister was married to William Fry (seventh generation from Thomas). Beginning with the founding of the town in 1677, the Fry homestead farm has belonged to nine generations of Frys and has been in continuous operation as a farm. After the East Greenwich Land Trust was established in 1987, Dorothy E. and Marion L. Fry donated 46 acres of pristine woodland to be called Fry Family Nature Preserve. Fry's Hamlet is still agricultural in nature today, with fields and pastures supporting the Baileys' dairy cattle. The farmlands, transected by stone walls and paths developed over 250 years, constitute an important survival of the agricultural landscape of East Greenwich.

The historic character of Fry's Hamlet is emphasized by the adjacent suburban development, which includes industrial plants to the north and south, a superhighway on the east, and modern housing throughout the surrounding area.

SECOND FARM IN FRY'S HAMLET. In 1798–1799, Thomas Fry IV (1765–1831) purchased the former Walter Spencer farm on the east side of Route 2. A detailed account book kept between 1795 and about 1833 provides transactions between the Frys and Stephen Arnold, a merchant in East Greenwich village, in which butter, cheese, wood staves for hogsheads, and other produce were exchanged for molasses and other imported goods. A similar kind of bartering was made with Davisville Textile Factory, with farm produce being exchanged for broadcloth and custom work on homespun cloth. Other accounts refer to firewood sent to Newport and other woods (probably black walnut) sold to furniture makers. (J. R. Cole's *History of Washington and Kent Counties*.)

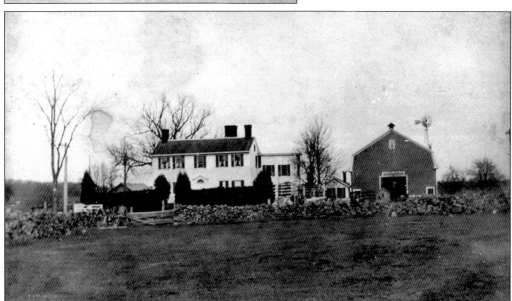

THE SPENCER-FRY-VAUGHN HOUSE AND BARN. This 18th-century house is two and a half stories, with center chimney and a two-story, five-bay Federal front addition with two internal gable end chimneys. Thomas Fry IV (1765–1831) purchased the former Walter Spencer farm. This went to his son Thomas Greene Fry (1810–1892), who married Hannah Spink. Their daughter Lydia Fry married William A. Vaughn, who built the large barn around 1860, which blew down in the 1938 hurricane.

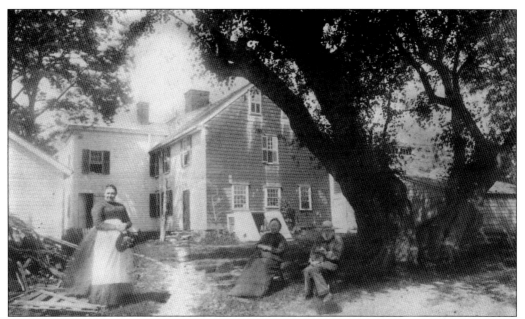

WARM AFTERNOON. This scene is at the rear, the oldest part, of the Spencer-Fry-Vaughn House. Lydia Vaughn (née Fry) is shown standing with her parents Hannah Fry (née Spink) and Thomas Greene Fry, both seated. (Fry-Bailey photograph.)

FAMILY PORTRAIT. Mary Elizabeth (Lizzie) Fry (née Bailey) sits with her son Louis and dog in the horse-drawn buggy while father William Greene Fry stands beside daughter Maud. This picture was taken in late 1880s in the meadow behind the barn. (Fry-Bailey photograph.)

JOSEPH FRY FARMHOUSE. This house faces west on Route 2, the South County Trail. It was completed in 1795 and is attributed to Browning Nichols of East Greenwich. It is a two-and-a-half-story frame Federal residence with a complex of barns, sheds, and outbuildings built to its rear over the past 200 years. It replaced an earlier house that burned in 1793. (Fry-Bailey photograph.)

SPENCER-BAILEY HOUSE, BUILT AROUND 1735. This house is 400 yards north of the Spencer-Fry House and has an off-center chimney. An addition on the southern end was added in 1759, according to a date stone in the foundation. John Spencer presumably built the addition. The house was built on a bank, and its cellar has a ground-level entrance on the south end. (Fry-Bailey photograph.)

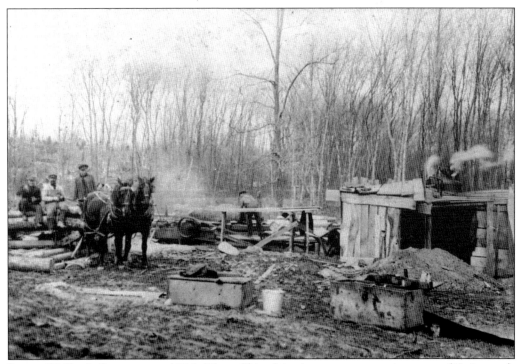

LOUIS W. FRY'S SAWMILL, c. 1900. The mill in this picture was set up in a part of Fry's woods known as Maple Swamp.

APPRECIATION. In appreciation of their tireless dedication to preserving the written history of the town of East Greenwich, which has saved endless hours of research, the authors of this book honor these three notable women (counterclockwise): Marion L. Fry (1912–1995), teacher, civic leader, and preservationist; Violet E. Kettelle (1905–2004), teacher, historian, and author; and Mary Nichols Rice (1913–1998), librarian, historian, and preservationist.

BIBLIOGRAPHY

Cole, J. R. *History of Washington and Kent Counties*. New York, NY: W. W. Preston & Co., 1889.
Downing, Antoinette F. *Early Homes of Rhode Island*. Richmond, VA: Garrett & Massie, Inc., 1937.
East Greenwich Academy Catalogue, 1890.
East Greenwich Chamber of Commerce. "East Greenwich Welcomes New Industry." *Providence Sunday Journal*, June 23, 1957.
East Greenwich Chamber of Commerce. *Welcome to East*. East Greenwich, RI: Weaver Publishing Co., Inc., 1990.
East Greenwich Preservation Society. *A History of East Greenwich, Rhode Island*, as published in the East Greenwich Packet. East Greenwich, RI: East Greenwich Preservation Society, 1996.
East Greenwich, Rhode Island, 250th Anniversary Celebration of the Founding, September 4–8, 1927. Souvenir Program. Providence, RI: Akerman Standard, 1927.
East Greenwich Tercentenary Commission. *East Greenwich, R. I., 300 Years, the Tercentenary Book, 1677–1977*. Rhode Island Pendulum, July 1977.
East Greenwich Town Records. East Greenwich Tax Book, 1974.
Eldredge, Dr. James H. "Dr. James H. Eldredge Remembers East Greenwich."
Greene, D. H., M.D. *History of the Town of East Greenwich and Adjacent Territory from 1677 to 1877*. Providence, RI: J. A. and R. A. Reed, Printers and Publishers, 1877.
Holst, Anne Crawford Allen. Newspaper article. *Rhode Island Pendulum*, March 23, 1950.
http://www.royalarcanum.com.
Kentish Guards. *Two Hundredth Anniversary*. East Greenwich, RI: Saturday, October 19, 1974.
Kettle, Violet F. *The Rural Roads in East Greenwich in the Teens and Twenties of 1900, Their Farms and Owners with Some History*.
King, H. Irving. *An Account of the 250th Anniversary Celebration of the Founding of the Town of East Greenwich*. East Greenwich, RI: The Greenwich Press, 1930.
Latimer, Sallie Wharton. *The History of the Huguenot French Settlers in the Colony of Rhode Island, A Compilation*. Narragansett, RI: Narragansett Historical Society, August 16, 1986.
League of Women Voters of East Greenwich. *Facts about East Greenwich*. Revised and Edited, 1957.
MacGunnigle, Bruce Campbell. *East Greenwich, Rhode Island Historical Cemetery Inscriptions*. East Greenwich, RI: Minuteman Press, 1991.
McPartland, Martha H. *The History of East Greenwich, Rhode Island, 1677–1960 with Related Genealogy*. East Greenwich, RI: Fast Greenwich Free Library Association, 1960.
Pawtuxet Valley Gleaner Weekly. "Our Village Record, No. 1." East Greenwich, Christmas 1890
Providence Journal and *Providence Sunday Journal*. "The Rhode Islander." Sunday, August 28, 1966.
Rhode Island Historical Preservation Commission. Statewide Preservation Report K-EG-1: East Greenwich, Rhode Island, August 1974.
Rhode Island Historical Society. *Rhode Island History*. Vol. 26, Nos. 1 and 11. Providence, RI: January 1967.
Rhode Island Monthly magazine. November 1994.
Rhode Island Pendulum. Obituary of William H. Taylor, December 21, 1939.
Rhode Island Pendulum. 125th Anniversary Edition, Sections A, B, C, D, 1979.
Turner, Henry F. "Reminiscences of East Greenwich." Address delivered before the East Greenwich Business Men's Association, April 11, 1992.
Weaver, Lucius F. *History and Genealogy of the Weaver Family*. Rochester, NY: DuBois Press, c. 1928.

ACROSS AMERICA, PEOPLE ARE DISCOVERING SOMETHING WONDERFUL. THEIR HERITAGE.

Arcadia Publishing is the leading local history publisher in the United States. With more than 3,000 titles in print and hundreds of new titles released every year, Arcadia has extensive specialized experience chronicling the history of communities and celebrating America's hidden stories, bringing to life the people, places, and events from the past. To discover the history of other communities across the nation, please visit:

www.arcadiapublishing.com

Customized search tools allow you to find regional history books about the town where you grew up, the cities where your friends and family live, the town where your parents met, or even that retirement spot you've been dreaming about.